WITHDRAWN

MUSEUM OF FINE ARTS • BOSTON, MASSACHUSETTS

Roy Lichtenstein

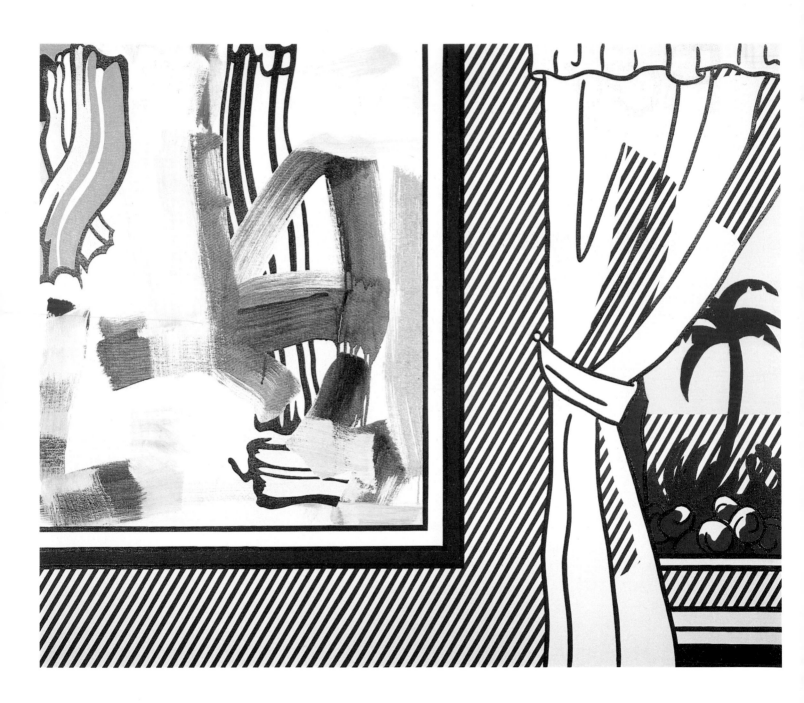

Painting Near Window, 1983
Oil and Magna on canvas, 50 x 60 in.
Private collection

MODERN MASTERS SERIES

Roy Lichtenstein

Lawrence Alloway

ABBEVILLE PRESS · NEW YORK

Roy Lichtenstein is volume one in the Modern Masters series.

To Sylvia

Art director: Howard Morris
Designer: By Design
Editor: Nancy Grubb
Picture researcher: Christopher Sweet
Production manager: Dana Cole
Chronology, Exhibitions, Public Collections, and Bibliography
compiled by Anna Brooke

FRONT COVER:
Oh, Jeff . . . I Love You Too, But, 1964
Acrylic on canvas, 48 x 48 in.
Stefan T. Edlis

BACK COVER:
Portrait of a Woman, 1979
Plate 100

END PAPERS:
Roy Lichtenstein, 1981
Photographs by Michael Abramson

Marginal numbers in the text refer to works illustrated in this volume.

Library of Congress Cataloging in Publication Data

Alloway, Lawrence, 1926–
 Roy Lichtenstein.

 (Modern masters series)
 Bibliography: p.
 Includes index.
 1. Lichtenstein, Roy, 1923– . I. Lichtenstein,
Roy, 1923– . II. Title. III. Series.
N6537.L5A84 1983 759.13 83-2788
ISBN 0-89659-330-4
ISBN 0-89659-331-2 (pbk.) ISSN 0738-0429

First edition

Contents

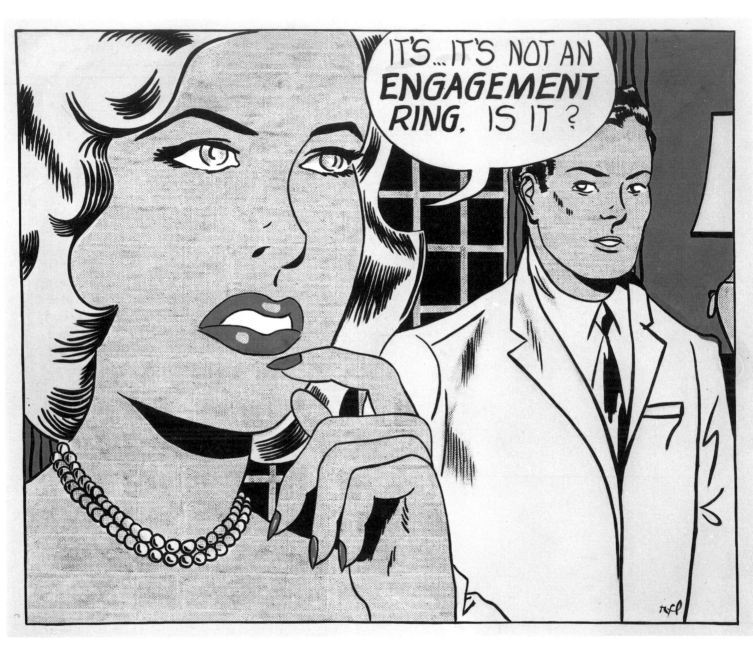

1

Introduction

This book begins in the early 1960s, when Roy Lichtenstein was an exhibiting artist with more than ten years' work behind him. That early work includes imagery of the nineteenth-century Far West and of American history, painted 1952–55, and an Abstract Expressionist phase, 1957–60. Why start a book on an artist *after* such well-developed periods? In 1961, my starting point, Lichtenstein's paintings became flatter, simpler, and more highly finished, but at the same time he embraced popular culture as subject matter. This is the point at which his personal career converged with the public interest or, to put it another way, when he entered contemporary art history. Lichtenstein became a representative artist of his generation (born in the 1920s), in the most demanding art center in the world—New York. That is the reason for starting at this date.

It is not my purpose to minimize Lichtenstein's origins—and indeed, some of this early work is reproduced here—but it seems more appropriate for the present to discuss the unity of his work in the last twenty years, as opposed to a recent tendency to divide it, and to discuss iconography as an intrinsic part of his art, hence the long chapter on the uses of quotation (chapter 5). I assume him to be a painter first, and since this is a short book I have concentrated accordingly on what seems to be the mainline, although the various periods of his sculpture are discussed briefly.

If we follow the sequence of an artist's development, as the monograph form invites us to do, we are essentially involved in an act of shadowing. The written account is an analogue of the order of events, stylistic or biographical, in the artist's life. Biography today is stretched between revelation and gossip. The revelatory mode shows the artist in extreme states of stress (Vincent van Gogh, Jackson Pollock), and gossip shows the artist as being like ourselves in the short term (Calvin Tomkins's book on Robert Rauschenberg is like this). The drama of the first mode is not Lichtenstein's style, and he has successfully avoided the domain of gossip. Biography in his case therefore rests largely on his profession; this withdrawal of art from the demonstrative can also be

1. *Engagement Ring*, 1961
Oil on canvas, 67¾ x 79½ in.
Private collection

seen in studies of Frank Stella by William S. Rubin and Ellsworth Kelly by Eugene C. Goossen.

Lichtenstein was born in New York in 1923 and attended the Franklin School. Art was not taught there but he drew and painted at home, and when he left high school enrolled in summer art classes at the Art Students League under Reginald Marsh. He entered the School of Fine Arts, Ohio State University, in 1940 and was much influenced by Hoyt L. Sherman's systematic analysis of picture construction. After being drafted by the U.S. Army and serving from 1943 to 1946, he returned to Ohio State to get his B.F.A. in 1946 and M.F.A. in 1949. In the 1950s he held several one-artist shows in New York galleries and taught, first at the State University of New York at Oswego and then, from 1960 to 1963, at Douglass College, Rutgers University, New Jersey. Here his contact with artists was extended to include Allan Kaprow, George Segal, and Robert Watts, among others. Thus he occupied a solid professional niche when in 1961 he began his Pop paintings.

In the 1950s, when he was both teaching and painting, Lichtenstein was acting as many artists do who need a second job to survive. In 1961 the original way of working that he formulated proved to have analogies with that of his contemporaries, and as soon as 1962 he was taken on by an exceptionally influential dealer, Leo Castelli. With his backing Lichtenstein was able to support himself purely as an artist, and in 1964, after a year's leave of absence from Rutgers University, he resigned from teaching. Lichtenstein responded to this freedom by producing an abundant oeuvre, both purposeful and varied, as we shall see. His success was remarkable, leading to early retrospectives: in 1967 at the Pasadena Art Museum and two years later at the Solomon R. Guggenheim Museum, New York, both of which traveled to other museums in the U.S. and Europe. Given Lichtenstein's reticence and his concentration as an artist, his biography is identified with his production rather than events outside the studio. The graph of professional achievement replaces the erratic tracks of personal day-to-day behavior. The artist's development becomes of prime significance, not as it produces timeless objects but as a record in time of work done. This is not art for art's sake but art as evidence of a work ethic, validated by intensity of production and the pace of coherent change.

The logical succession of Roy Lichtenstein's work, as we shall see, lends itself to a chronological ordering. The chief risk in this lies in the possibility of missing other kinds of order. Because the chronicle form emphasizes linearity it may lose sight of patterns of thematic recurrence, which call for a mode of criticism that crosses time rather than follows its succession. In what follows I have tried to indicate such recurrences, including the reappearance of the single image at different points in Lichtenstein's work and his changing use of other people's art.

There is a large picture book on Lichtenstein's work of the 1960s by Diane Waldman and a book on the work of the '70s by Jack Cowart, both based on exhibitions.[1] This monograph, covering both decades, aims to show Lichtenstein's work as a continu-

ous project. Introductions are written after books are finished, when the author knows what he or she has done, and this turned out to be my purpose: I want to represent Lichtenstein's work from 1961 as a unity, though not a simple unit.

According to Cowart, "by 1970 the artist had left a Pop style and begun to employ new compositional lines."[2] He proposes a chronological break in the artist's development—Pop art and after, coinciding with the two decades—but is it real? As I see it, the decades are linked stylistically and psychologically: the aesthetic premises of the 1960s are maintained, but amplified and enriched. When Lichtenstein began his paintings derived from comics in 1961 he was in his late thirties. What does one expect of artists at this time of life?: that they know their way and be in command of a personal style. For most artists, development consists in the extension, not repudiation, of the ideas of their early maturity. The mystique of the breakthrough, of the life remade, associated with Abstract Expressionism is rarely supported by specific examples. Lichtenstein, who was fifty in 1973, has kept his base in Pop art. This is the artist's own view: "'Almost everything I'm doing,' he says, 'I did in the 60's.'"[3] If this is the case, it is necessary to have a definition of Pop art that is in accord with Lichtenstein's subsequent practice. A broad definition of Pop art as art about signs seems more useful than the narrow one of art that uses commercial subject matter (see chapter 3). Like most American art movements since World War II, Pop art was never a group with a shared program, but the artists were affiliated by generational and ideological affinities, perhaps even by publicity.

To key Lichtenstein's later work to his earlier does not suggest repetition, simply a coherent progression. Something of this can be seen by comparing three paintings done over a period of eighteen years. *Engagement Ring* (1961) has its tentative aspects: the screen of small benday-type dots used for the flesh is patchy, and the drawing, especially of the suitor's coat, is staccato. The painting has a rawness that carries over something of the original impact of Lichtenstein's work from the 1950s: one red is used for fingernails, lips, drapes, and wall, and one yellow for the blonde woman's scooped hair and the lampshade on the opposite side of the picture. At the same time, we can see the artist approaching the integrated formality of his later work: *Engagement Ring* is a fully characteristic painting, conceptually and manually, but it lacks the seamless aplomb that he was shortly to achieve.

This can be seen handsomely in *We Rose Up Slowly* (1964). The woman is again blonde, the patterns of her hair echoed by undulant blue and purple lines that symbolize the underwater setting. The embracing couple occupy one panel and the caption a second: "We rose up slowly . . . as if we didn't belong to the outside world any longer . . . like swimmers in a shadowy dream . . . who didn't need to breathe . . ." The separation of words and image enables Lichtenstein to elaborate his linear and color conventions luxuriously. A part of this effect is the result of the tonal depth of the blue, which almost absorbs the sinuous black outlines. Also, the visual panel is square, providing space for a rich, equalized composition, neither horizontal nor vertical. The benday screens are

* Marginal numbers refer to works illustrated in this volume.

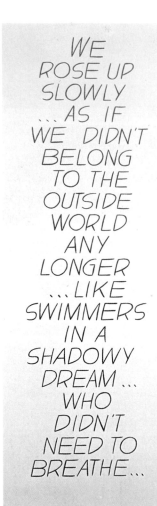

WE
ROSE UP
SLOWLY
...AS IF
WE DIDN'T
BELONG
TO THE
OUTSIDE
WORLD
ANY
LONGER
...LIKE
SWIMMERS
IN A
SHADOWY
DREAM...
WHO
DIDN'T
NEED TO
BREATHE...

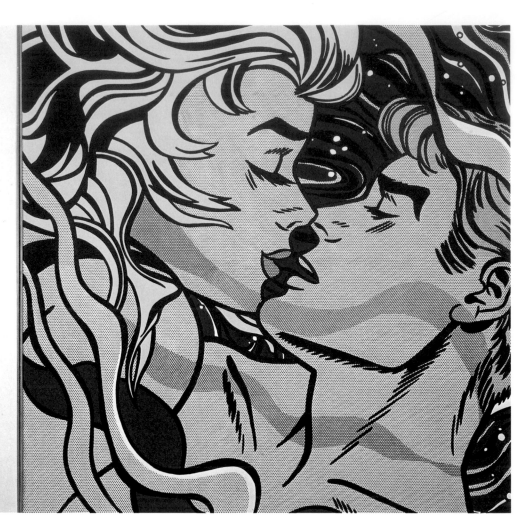

2

smooth and even, capable of delicate color adjustment: the element of approximation in *Engagement Ring* has been brought within a canon of control.

3　A later blonde appears in *Stepping Out* (1978), a picture that shows both the increasing systematization of Lichtenstein's procedures and the widening of his range of quotations. The woman is a Dali-esque invention, consisting of lips, one blue eye, and a hank of hair that flows before a small head-sized mirror. The male is quoted from late Fernand Léger. Lichtenstein's distribution of solid yellow, blue, and red and of graduated dots, larger than earlier, is as emphatic as it is elegant, both firm and smooth.

These are all images of couples and all are mediated by the use of preexisting signs. The first shows the momentous boundary between being unattached and committed, the second an ecstatic moment of erotic happiness, and the third presents sexual differences as an Ovidian metamorphosis. This suggests not that Lichtenstein is uninterested in the subject matter provided by his sources, as is often argued, but a thematic recurrence that may be expressive. For all the double-takes (it's a comic, it's a painting; it's a Léger, it's a Lichtenstein), the works draw on the theme of romantic love.

2.　*We Rose Up Slowly*, 1964
Oil and Magna on canvas, two panels,
68 x 24 in. and 68 x 68 in.
Hessisches Landesmuseum, Darmstadt
Sammlung Karl Ströher

3.　*Stepping Out*, 1978
Oil and Magna on canvas, 86 x 70 in.
The Metropolitan Museum of Art, New York

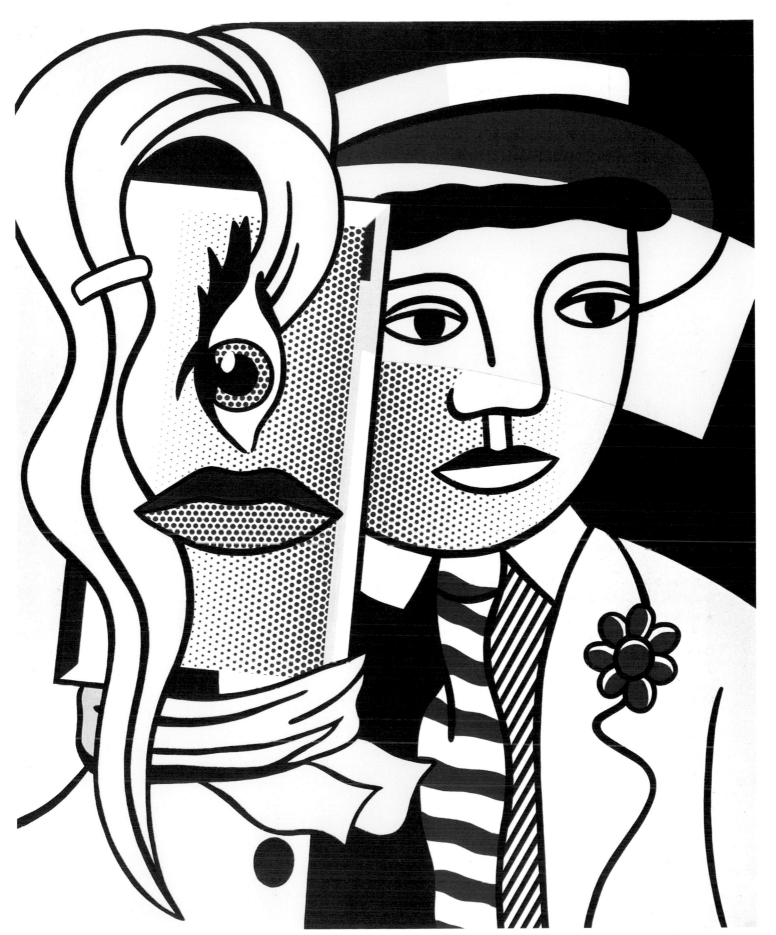

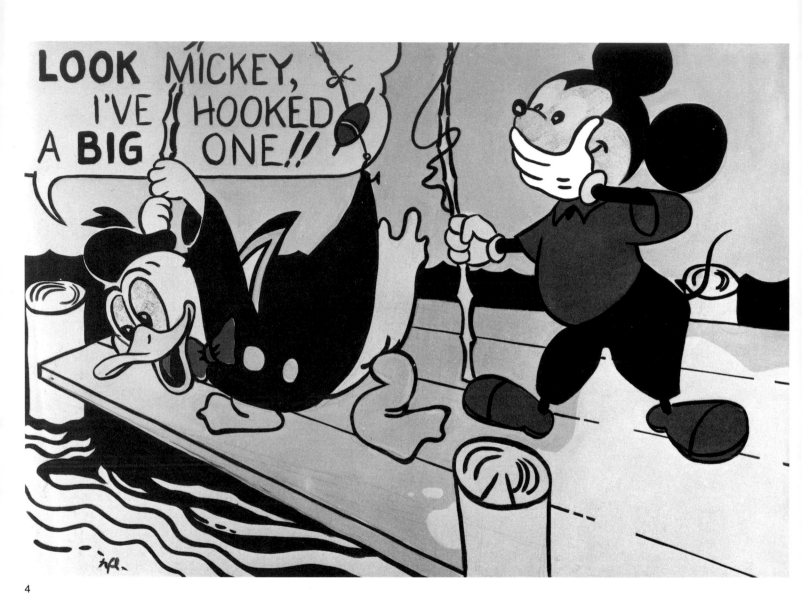

1 Comics and Objects

Lichtenstein is irrevocably associated with the comic books that he quoted in his paintings between 1961 and 1965. They were not his exclusive source, but the most significant one. The comics provided a basis for his strong black outlines and narrow range of colors, often applied through screens to simulate printed reproductions. The comics were more than a fund of imagery, though they were that; they were also a source of systematic technique. For example, Lichtenstein treated color, traditionally the mysterious and least defined element of painting, as if it were quantifiable, like printer's ink. A comics artist need not himself tint an area in a drawing; it is sufficient to specify color, numbering it for density. The comic takes on color for the first time when it is printed. By simulating this process by hand, Lichtenstein implicitly dismisses the Venetian and Rubensist tradition of color.

Comic strips occur occasionally in American art of the 1950s: in Robert Rauschenberg's combine-paintings, such as *Odalisque* (1955–56), which has a colored patch of "Beyond Mars" in it, and in Jasper Johns's *Alley Oop* (1958), where a block of the strip is evoked by solid dabs of paint. These are symptoms of a growing interest by artists in the messages and products of mass communications, but it was Lichtenstein and Andy Warhol who first made a consistent use of the comics. They worked independently of each other, with Warhol the slightly earlier of the two. Warhol painted *Dick Tracy* in 1960, for instance, where Lichtenstein's *Engagement Ring* is a year later.

That was the year Lichtenstein made his first paintings based on comic imagery, using characters like Popeye and, in *Look Mickey*, Donald Duck and Mickey Mouse. John Coplans pointed out that there are "minor changes in color and form from the original,"[4] and that the paintings are large in scale and "directly and loosely drawn." Unlike his later paintings, they deal with stock figures, as Warhol always does but Lichtenstein characteristically does not. The source of his first paintings from modern popular culture was not comic strips but bubble-gum wrappers that Lichtenstein got from his children. As a rule, his imagery is based on typical scenes

4

4. *Look Mickey*, 1961
Oil on canvas, 48 x 69 in.
Private collection

5

from the comics with once-only characters: his is a naturalistic use of the comics in that sense.

Later in 1961 Lichtenstein began the paintings that are continuous with the later work. He declined completely the painterly potential of his own paraphrases of nineteenth-century Western narrative paintings of the 1950s, while keeping his fondness for allusion and games of style. He adopted a lean, flat way of painting that defined the picture plane as a finite zone in opposition to the spatial play of Abstract Expressionism. He used an iconography of household objects, drawn particularly from the kitchen, and, increasingly, of scenes from the comics.

Lichtenstein's resistance to the subjectivity and otherworldliness that had become attached to art shows markedly in his single-image paintings, which are mostly derived from product catalogs and advertisements: one work of 1961, *Kitchen Range*, painted in blue and yellow, even carries the copyright mark of the manufacturer. *Roto Broil* of the same year is another object presented in its completeness, with no modifying objects round it and no plane for it to stand on. It occupies the picture-plane emblematically, centralized and head-on. Both works are comparatively tentative in execution compared to the later pieces, but their initial impact should not be underestimated: something of the starkness of a Marcel Duchamp Ready-made, a manufactured article taken as is, has been transferred to painting. The appearance of these and other images in the group is semimechanized, though the dots, imitated from benday screens, are more impressionistic and the contours less emphatic than in later paintings. The dots were stenciled but the holes in the screens were small, with the result that the imprint was often parched or clogged and, the artist recalls

5. *Inside Fort Laramie*, 1955
Oil on canvas, 30 x 36 in.
Private collection

6. *Roto Broil*, 1961
Oil on canvas, 68½ x 68½ in.
Private collection

14

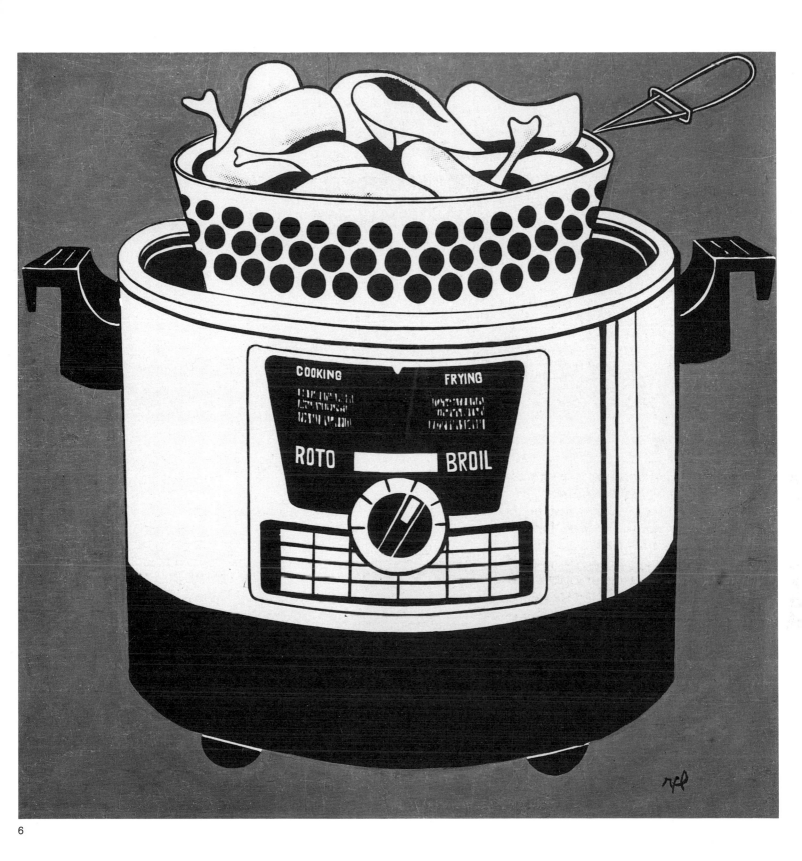

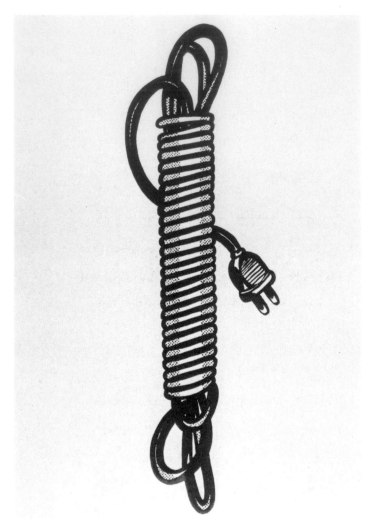

7

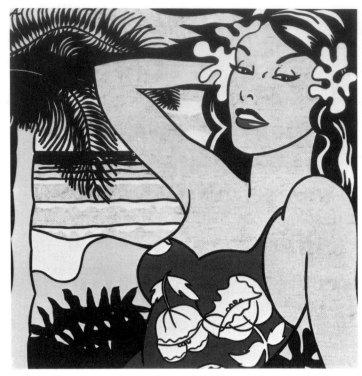

8

wryly, had to be made impersonal looking by manual corrections. Like several of his contemporaries (Jim Dine, Claes Oldenburg, Andy Warhol, Tom Wesselmann), Lichtenstein was interested in the mechanical products that postdate the handcrafted objects of cultivated taste that are the basis of still-life painting.

 Though using ephemeral printed material, Lichtenstein solicited from it, by means of simplification and enlargement, a style of 7 monumental presence. Probably *Electric Cord* (1961) is the first single-object painting to have the *thereness* that Lichtenstein's sense of things required. The cord is painted before use, wrapped tightly, like a spiral staircase, with a loop at one end with the plug. George Maciunas coined the word *monomorphic* for single-event art, and it is appropriate to Lichtenstein's epigrammatic, deadpan paintings of objects in their singleness. Object painting is not still life as usually defined, taking this to mean a relationship among a 12 plurality of objects. *Golf Ball* (1962) is an especially good example: the image sits there as starkly as a granite cannon ball, but the indented pattern is as systematic as Mondrian's plus-and-minus drawings and even implies a computer's binary print-out. The mixture of visual clout and logical procedure continues in various

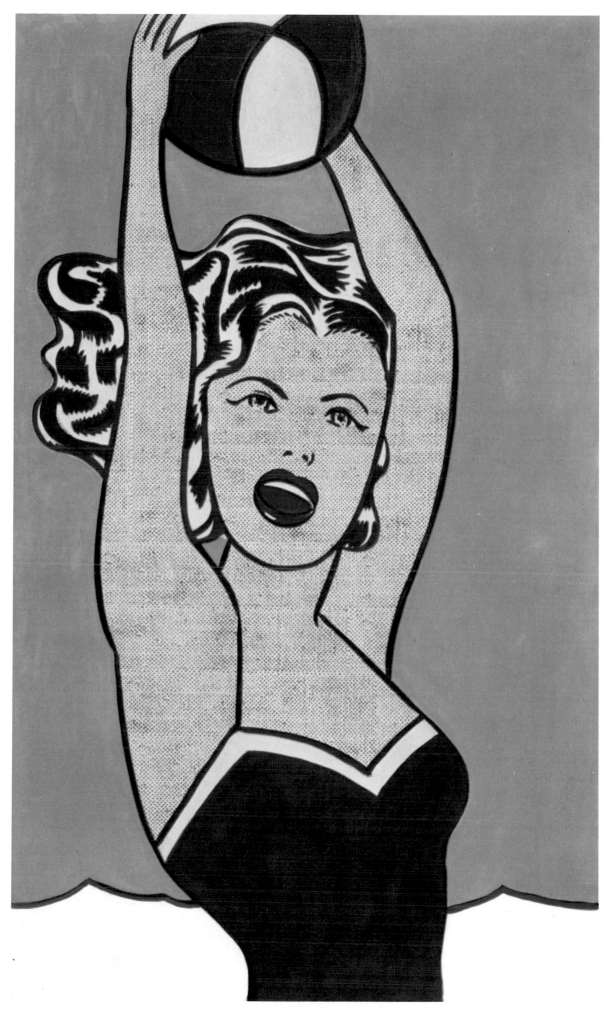

17

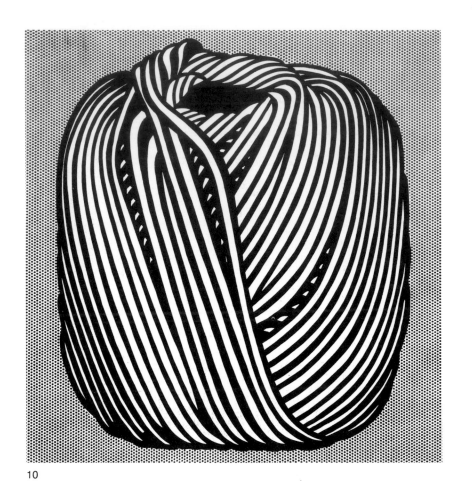

10

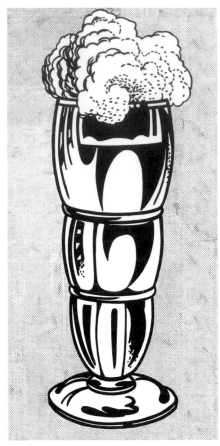

11

forms after 1963 when the single-image painting ended.

Figure paintings in a dry rather than a loose style date from 1961, like *Engagement Ring*, in which the color compression and linear simplification of the comics are dilated to the scale of easel painting, in this case 5′8″ by 6′8″. *Girl with Ball* is taken from a one-column newspaper ad enlarged to a painting 5′ x 3′. A bouncy woman in a one-piece swimsuit catches or throws a striped beach ball, the red slices of which correspond to the color of her lips and open mouth. Its source is an ad for a resort in the Poconos, which is still being used in newspapers twenty years later. The longevity of the image is informative; Lichtenstein was looking for durable imagery in popular culture.

Some of Lichtenstein's paintings of 1962 maintain the hesitant, exploratory character of 1961, but others display a confident authority. This is particularly evident in the single-image paintings, which take on a Rock of Gibraltar–like thereness, and in the paintings from war comics, which have a clarity and elaboration in advance of the comparatively constrained romance subjects. It is in these works that Lichtenstein demonstrated his sense of pictorial completeness, a constituent of his mature art, for the first time. One step was to standardize the contour, so that the lines around objects became more uniform, solidifying the inflections that remained in 1961 from his painterly days. He presents the single objects as impacted configurations, like *Golf Ball*. *Ice Cream Soda*

10. *Ball of Twine*, 1963
Magna on canvas, 40 x 36 in.
Hessisches Landesmuseum, Darmstadt
Sammlung Karl Ströher

11. *Ice Cream Soda*, 1962
Oil on canvas, 64 x 32 in.
Private collection

12. *Golf Ball*, 1962
Oil on canvas, 32 x 32 in.
Mr. and Mrs. Melvin Hirsh, Beverly Hills

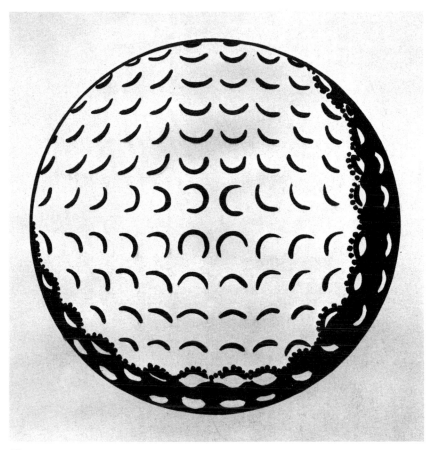

12

is no less monolithic, but the sliding forms of the three stories of the glass are more elaborate, like the hairdo of the woman in *Head —Yellow and Black*. Incidentally, these formal discoveries of Lichtenstein's arose from the environment: he told me in 1962 that the soda came from the menu of a diner in New Jersey and the head from a hairdresser's ad in the Yellow Pages, hence the allover color.

At the core of Lichtenstein's paintings of objects is a drive to simplify representational art so that it has something of the visual impact of contemporary abstract painting. An analogous desire to make a nonabstract art that was competitive in its color intensity and simplified surface can be found in Alex Katz's paintings of c. 1962–64. However, Katz is essentially a realist, for all his stylization, concerned with preserving the visual unity of the field of perception, of things seen in space, whereas Lichtenstein, though representational, is not a realist. He is concerned with subjects that already exist in sign form, things coded, but both artists draw from abstraction to maximize their different kinds of imagery. Robert Indiana's word and number paintings of the early 1960s have a similar combination of flat, clear display and quotidian references. Tom Wesselmann's Great American Nude series of the same time took Matisse's late two-dimensional figures as the basis for a play with pinup imagery, which is comparable with Lichtenstein's intersection of popular culture and high art.

13

Lichtenstein's mode emerged in 1961, was fully realized in the following year, and was assimilated by 1963. By then, the mechanics of impact had been mastered, and the monomorphic forms had been progressively replaced by figures derived from the comics, in which visual clout was accommodated to more complex forms. Of the war images, *Blam* and *Takka Takka* (both of 1962) are particularly successful in their combination of brilliant color and narrative situation, but *Live Ammo, Flatten . . . Sand Fleas, Whaam!*, and others reveal the same impetus.

15,25

The range of allusions from anonymous urban culture to specific fine artists, as well as the distance between low sources and the high-art form—easel painting—into which they were absorbed, gave Lichtenstein great flexibility. There is a spectrum of possible interpretations as mass denotation and elite connotation collide and diverge.

Lichtenstein takes pleasure in a mask of simplicity. It is remarkable in retrospect the extent to which many critics took the dumb look of the paintings at face value. They did so because they were bound by notions of seriousness inherited from earlier twentieth-century art, which, however innovative originally, had been blunted by solemnity. Lichtenstein's apparent passivity seemed to be a denial of the personal element in art; his covert transformations, which we will discuss in some detail, were missed at first.

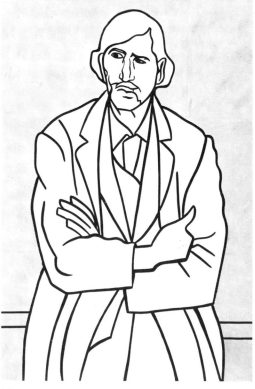

14

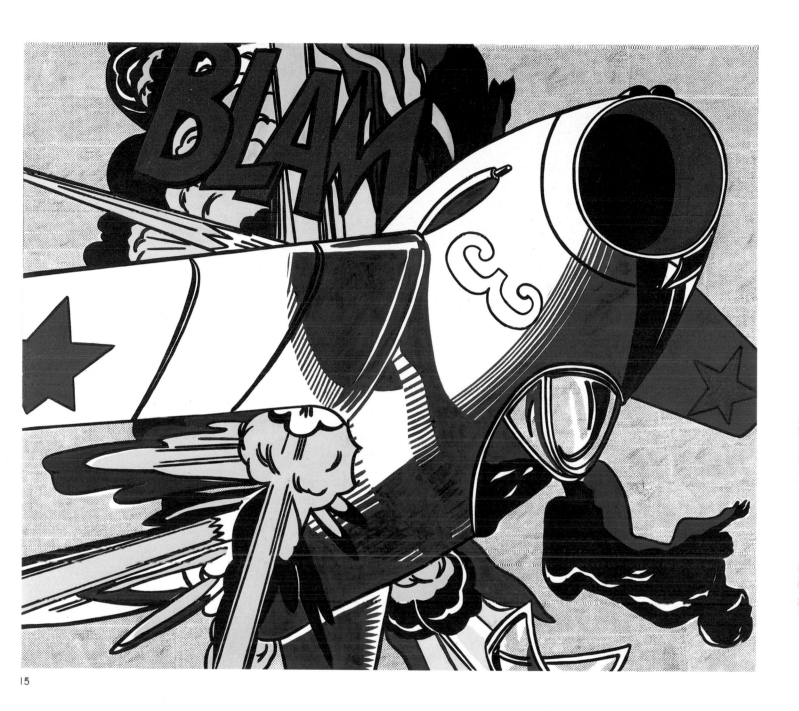

15

13. *Head—Yellow and Black*, 1962
Oil on canvas, 48 x 48 in.
James Goodman Gallery, New York

14. *Man with Folded Arms*, 1962
Oil on canvas, 70 x 48 in.
Private collection

15. *Blam*, 1962
Oil on canvas, 68 x 80 in.
Richard Brown Baker Collection
Courtesy of Yale University Art Gallery

Aside from the formal solidification of Lichtenstein's painting in 1962, there is an iconographical aspect that must be discussed. It was a marvelous year in which the basis of many developable ideas was laid. There was the climax and phasing out of the single images and the decisive entry of the iconography of the comics. At the same time, the theme of art emerged. Lichtenstein made a *Portrait of Mme. Cézanne* and *Man with Folded Arms*, taken not directly from Cézanne but from diagrammatic analyses of the paintings by Erle Loran. We shall see the ramifications of this choice in the later work of Lichtenstein. It shows, combined with different approaches to the comics, that the quotation of popular culture was not the sign of intelligence suspended but rather the shape of thought.

14

I TRIED TO
REASON IT
OUT / I TRIED
TO SEE
THINGS FROM
MOM AND
DAD'S VIEW-
POINT / I
TRIED NOT TO
THINK OF
EDDIE, SO
MY MIND
WOULD BE
CLEAR AND
COMMON
SENSE
COULD
TAKE
OVER / BUT
EDDIE
KEPT
COMING
BACK ...

16

2 Pop Culture and Fine Art

When Lichtenstein's paintings were new and unfamiliar, art critics who did not know much about comics assumed that his art and its sources were identical. This is far from the case, but believing it to be so fed the opinion that art with a source in popular culture appealed to the same "base" appetites as the originals. Hence, a work of art that legibly quoted a commercial product equaled a commercial work of art. Lichtenstein has become a highly successful painter in the subsequent twenty years, but his reputation lies completely within the fine arts. He has shown no interest in reaching a wider audience, even on appropriate occasions. For instance, his *Mermaid* (1979), an outdoor sculpture installed in Miami as part of the Art in Public Places program, is not notable for addressing a wider audience than usual. The *Mermaid*, with a hank of blonde hair, bouncing on three waves under the stylized metal rays of the sun, is geographically apt, but it has more to do with Lichtenstein's paintings of the preceding two years than with the community. This is not said as a complaint, but as a corrective to the idea that an artist who quotes the mass media can only have mass audiences in mind. When Lichtenstein painted a big mural for Expo '67 in Montreal his procedure was similar: he enlarged an existing element in work on which he was then engaged, in this case the modular grid of his Modern paintings. He is not, in fact, particularly responsive to external stimuli in his art, except as iconography. Though his easel paintings contain numerous media references, it is in terms of quotation rather than in search of public contact.

The reaction of professional comic-book artists to Pop art in 1962 is relevant here. Their initial response was amazement to find themselves quoted or imitated by fine artists: one of the artists, recognizing a drawing of his as the source of a painting, said "I'll sue," but did not and never intended to. The artists were critical of Lichtenstein's work, as if he were trying to be a comics artist on their terms. They faulted his use of detail and especially the stylization of the paintings. His images were too flat and static for the spatially oriented, choreographic plausibility of modern

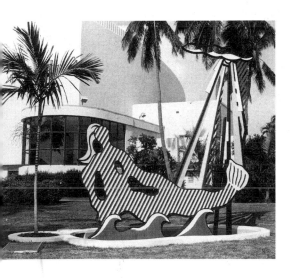

16. *Eddie Diptych*, 1962
Oil on canvas, two panels, 44 x 52 in. overall
Mr. and Mrs. Michael Sonnabend, New York

17. *Mermaid*, 1979
Concrete, steel, polyurethane paint, water, and palm tree, 21 x 24 x 11 ft.
Miami Beach Theatre for Performing Arts, Florida

narrative strips.[5] Essentially the commercial artists, to call them that, were in agreement with Lichtenstein, who always emphasized the unlikeness within the likeness of his comics imagery.

Twenty years ago the status of the comics was not what it is now. They were an acknowledged but ignored part of popular culture, for adults on Sunday and for children all the time. "Tijuana bibles" (obscene comic books) no longer existed and underground comics had not yet appeared. Nonetheless, comics were, as we saw, occasionally cited by artists as signs of the world outside art. Lichtenstein used comic books at a time when they offered, for those who could see it, maximum information. Though a "discredited area," in the artist's term, they were at a lively point of development, with many different titles. The cycles of energy and depletion that can be found in all fields of art are conspicuous in popular culture. Earlier comics would have provided nostalgic stereotypes, and later ones are diffuse and repetitive.

Comics are a mixed form, of course, combining verbal and visual discourse. In art, the weight of twentieth-century theory has been on the side of medium purity, despite Cubist and Dada collage and Surrealism. Lichtenstein's use of words not only resists implicitly the pressure for pure-medium art, it brings the tensions of high and low art into the structure of painting. Verbal statements in his art range from one-word exclamations ("Tex!") to pop culture's vivid onomatopoeia ("Brattata") to extended commentary in the *Eddie Diptych*, *We Rose Up Slowly*, *Takka Takka*, and the second panel of *Live Ammo*, a polyptych of combined air, sea, and land warfare. In the second panel, above an eye and the rim of a steel helmet, is a ruminative thought-balloon. This is a painting that quotes as well as it reproduces:

> Right now . . . if they're watchin' me . . . they've got to make up their minds whether I DON'T know they're here . . . and will pass by . . . lettin' the outfit be sucked into a trap . . . or whether I KNOW they're here . . . and am about to fire at them! But where did they come from? Not the sea . . . we've had our eyes glued to it! And we know there ain't an airfield on this island! Where'd they come from? WHERE'D THEY COME FROM?

This, by the way, catches perfectly the effect of the influence of game theory on popular culture, as it brought decision making and probability into the foreground. Game theory entered popular culture in the 1950s, first in science fiction, then in war comics and detective stories.

The subject of *Takka Takka* (1962) is war, but it is also style. Lichtenstein's source is a panel in a comic book, and though he has changed it extensively, the total effect of the changes does not break with the image of the original. The flame at the muzzle of the machine gun and the flashes of an explosion in the background derive from Lichtenstein's knowledge of comics filtered through his own decorative sense. His solid color and flat pattern do not "de-comicize" the image since they resemble comics generically. He works at two levels: (1) from a specific drawing and (2) toward an idea, the cliché, that we all share about comics. One of the alterations he makes is this: his point of departure is a story panel

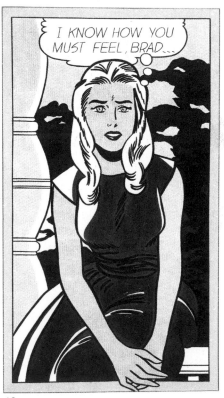

18

24

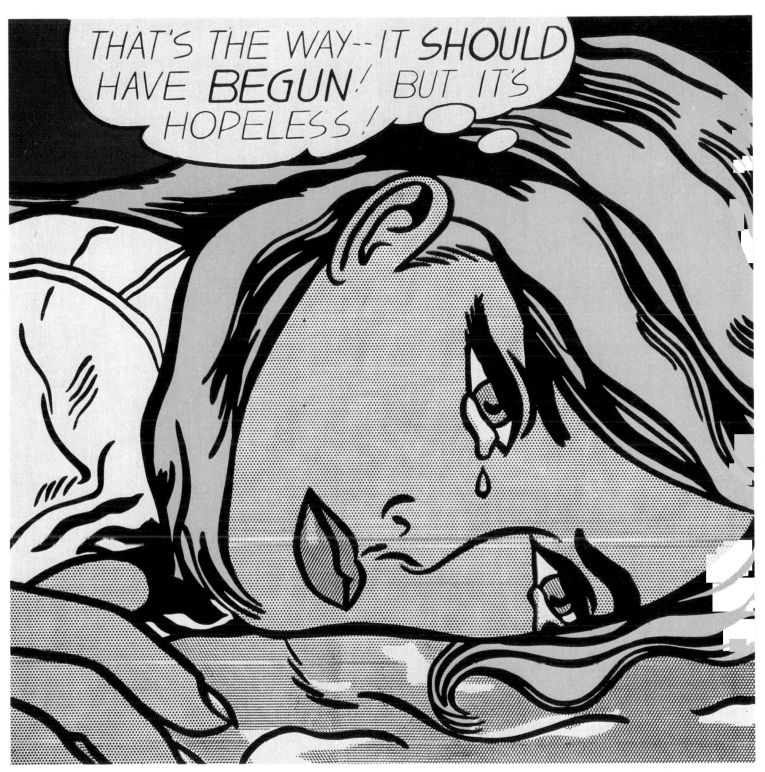

19

18. *I Know . . . Brad*, 1963
Magna on canvas, 66½ x 37¾ in.
Wallraf-Richartz Museum, Cologne
The Lugwig Collection

19. *Hopeless*, 1963
Oil on canvas, 44 x 44 in.
Wallraf-Richartz Museum, Cologne
The Ludwig Collection

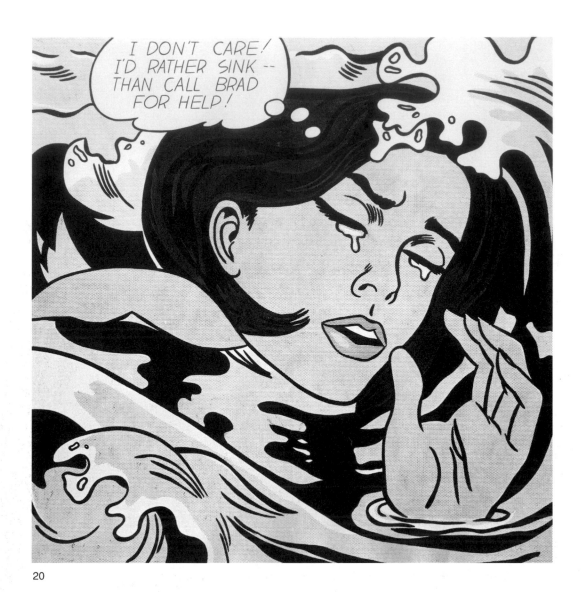

20

on the inside pages, but he transcribes it in terms of comic-book covers. Hence the higher degree of stylization and the emblematic fixity in place of narrative flow and pacing. The source of *Takka Takka* shows the barrel of a machine gun obliquely, from a low eye-level, with ejected bullet cases and a thrown grenade in mid-air —momentary images indeed. Also, there is a space burrowed back under the gun barrel to a gesturing hand, and an oblique horizon line leads into the distance. In the painting the gun is more nearly parallel to the picture plane, the bullet cases and the grenade form a kind of spray, and there is no oblique recession. In the comic the tight, narrow inscription is separated by a step from the visual action; in the painting there is a straight line, almost one-third of the way down the canvas, a visual detail typical of Lichtenstein's conversions. It has the effect of stabilizing a format that in its original form is unsettled and impressionistic.

Let us consider Lichtenstein as an editor in *Takka Takka*. The original inscription reads: "On Guadalcanal, the exhausted marines, sleepless for five and six days at a time, always hungry for decent chow, suffering from the tropical fungus infections, kept on

20. *Drowning Girl*, 1963
Oil and Magna on canvas, 67⅝ x 66¾ in.
The Museum of Modern Art, New York
Philip Johnson Fund and gift of Mr. and Mrs. Bagley Wright

21. *Brattata*, 1962
Oil on canvas, 42 x 42 in.
Teheran Museum of Contemporary Art

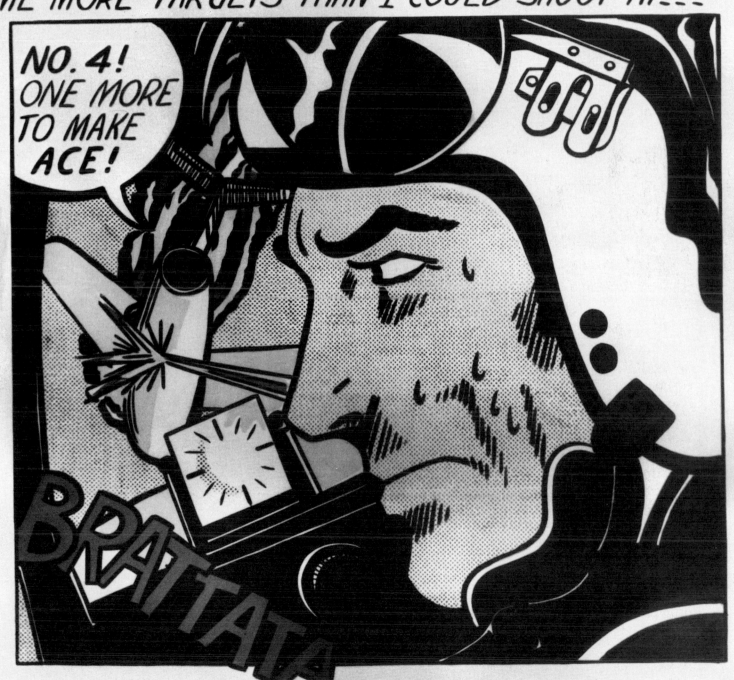

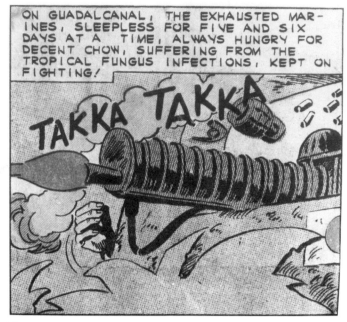

22

23

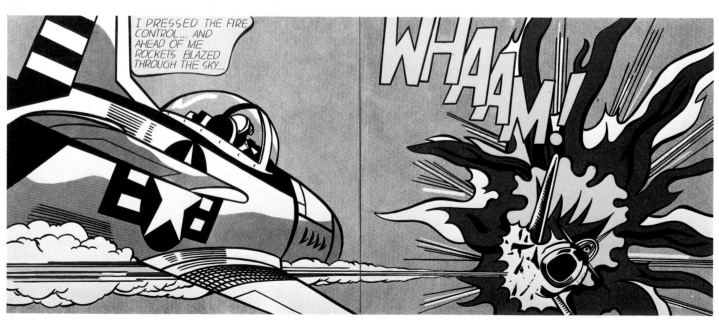

24

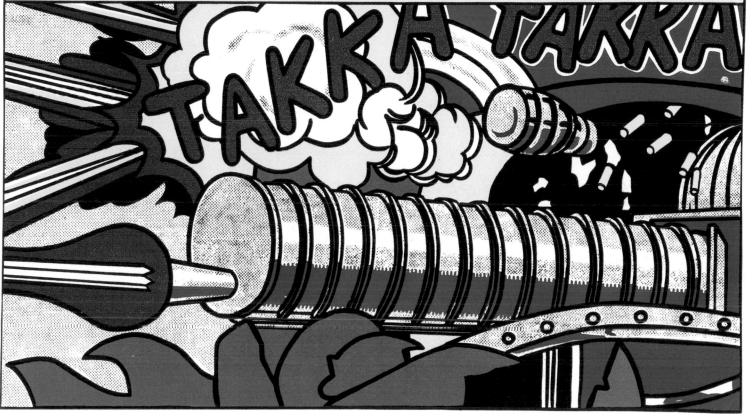

25

22. Source for *Takka Takka*

23. Study for *Whaam!*, 1963
Pencil on paper, 5⅞ x 12 in.
The Tate Gallery, London

24. *Whaam!*, 1963
Magna on canvas, two panels, 68 x 160 in.
overall
The Tate Gallery, London

25. *Takka Takka*, 1962
Oil on canvas, 56 x 68 in.
Wallraf-Richartz Museum, Cologne
The Lugwig Collection

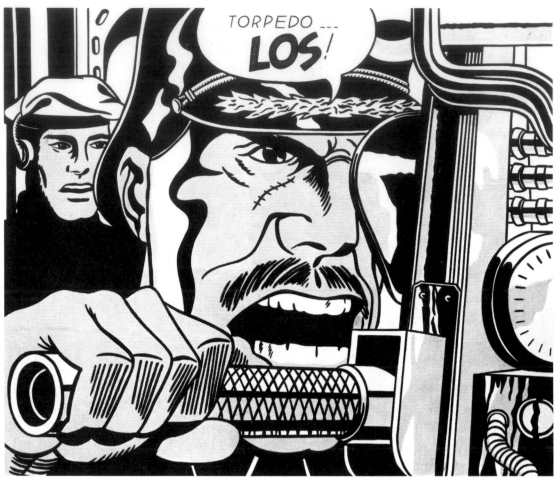

26

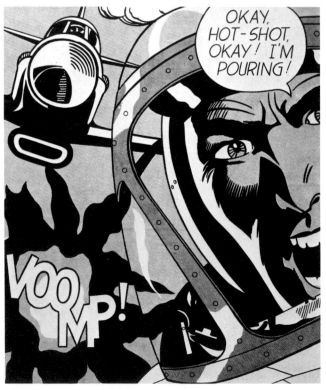

27

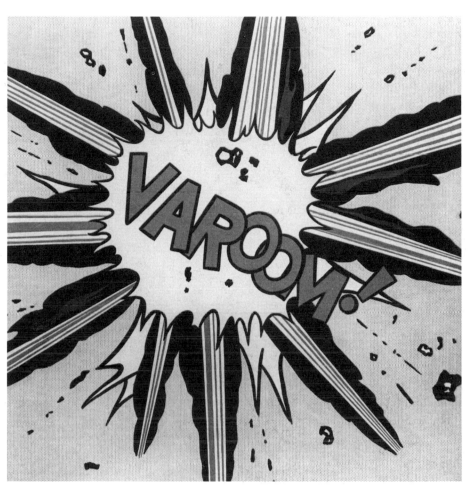

28

26. *Torpedo . . . Los!*, 1963
Oil on canvas, 68 x 80 in.
Mrs. Robert B. Mayer

27. *O.K. Hot-Shot*, 1963
Oil and Magna on canvas, 80 x 68 in.
Private collection, Turin

28. *Varoom!*, 1965
Magna on canvas, 56 x 56 in.
Kimiko and John Powers

fighting!'' Lichtenstein did more than devise a slimmer and more elegant alphabet for the inscription. Here is his version: ''The exhausted soldiers, sleepless for five and six days at a time, always hungry for decent chow, suffering from the tropical fungus infections, kept fighting!'' He has dropped the place location, changed *marines* to *soldiers*, and excised the slangy but redundant *on*. The changes are small but the cumulative effect is to generalize the combat and reduce the sense of narrative momentum, binding the words and image closer as a unified display.

The fact that words, directional in syntax and specific in reference, denote events in one way, and visual images, immediately present and spatially simultaneous, do it in another way was continually on Lichtenstein's mind. What follows from the variety of verbal activity in his visual fields? Did he dismiss words and return to a pure opticality, as is sometimes assumed? In fact, the multiple levels of signification recur in later works as the layering of diversified visual elements. Lichtenstein is not a collage artist, but his paintings contain quotations from his own work, from other artists, and from other styles. The work is full of allusions, and Lichtenstein's capacity to incorporate them in his work is as central to his practice as quotation was to Ezra Pound's.

Future research will no doubt come up with the names of the

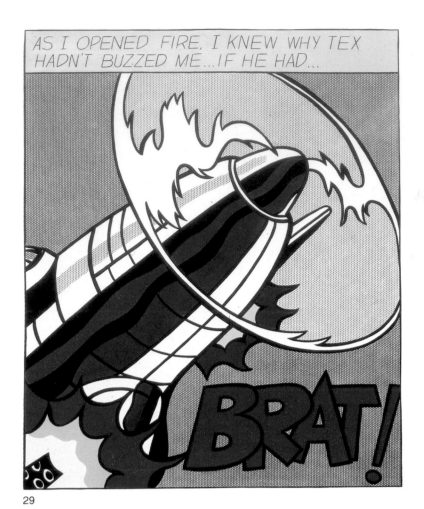

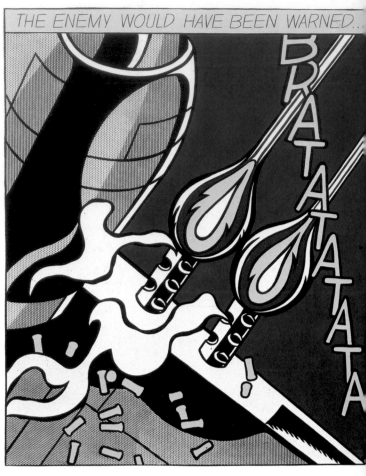

29

people who drew some of Lichtenstein's originals, but so what? That part of popular culture on which he drew was basically a fund of unattributed images and phrases. He was not engaged in mutual collaboration but in acts of annexation. In the 1950s and '60s popular culture was regarded widely as a system of common property to be claimed at will. Lichtenstein made a point of avoiding famous comic artists like Chester Gould or Al Capp. His iconography was based on style and genre, not on authorship. Thus Lichtenstein was not relying on the equivalent of *auteur* theory, in which fine-art authorship criteria are transferred to the movies, but viewing comics as a continuum of sharable images.

According to Alain Robbe-Grillet, "In contemporary art I have been very close to the experience of Roy Lichtenstein and of all that followed—which is to say, the integration in a plastic work of, on one hand, the objects belonging in an acquisitive society and, on the other, the images belonging to that society, the comic strips."[6] Robbe-Grillet is a novelist who was at first celebrated for his objectivity, for presenting the world of objects as it is, though it became apparent subsequently that the data were organized by strict principles of order. He seems to have recognized in Lichtenstein a similar contact with and ordering of the world. The comics-derived paintings, as they present schematic images of knowledge,

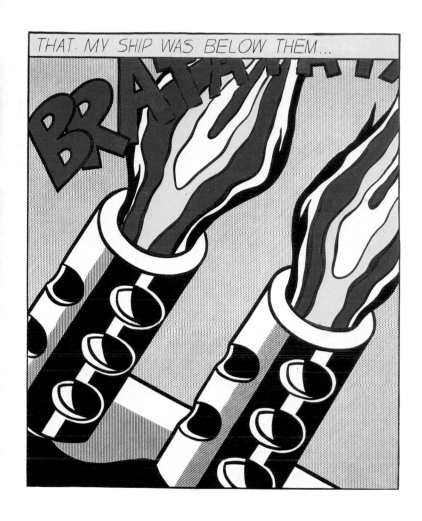

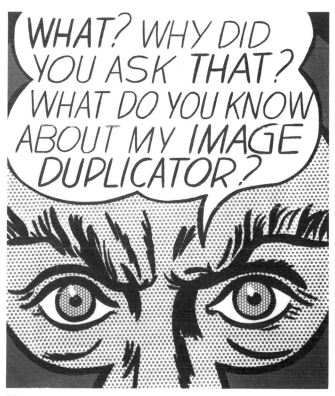

29. *As I Opened Fire*, 1964
Magna on canvas, three panels, 68 x 56 in.
each
Stedelijk Museum, Amsterdam

30. *Image Duplicator*, 1963
Magna on canvas, 24 x 20 in.
David Lichtenstein

30

engaged him particularly. We like to think of knowledge as a flexible, expanding store of information, but the fact is that it is also ideologically based and frequently stereotyped. By using the comics, as they deal with love and war, Lichtenstein sets these great themes in the context of schemata, vivid but artificial.

Lichtenstein's paintings regarded as schematic images of knowledge have misled many viewers of the work. There is the notion that flat pictures from popular culture are pictures of a flat world, one in which love is trivialized and war implicitly condoned because the images are not explicitly antimilitaristic. A related view supposes Lichtenstein to be a satirist whose low images in high style magnify the absurdity of popular culture and, by extension, the shallowness of those who use it. Robbe-Grillet expressed reservations about the artist's views as he understood them, but the affinity that the writer feels stands. Lichtenstein's subject is the artificiality of communication, the discrepancy between signifier and referent. Neither Robbe-Grillet nor Lichtenstein was at ease with the prevailing subjectivity and cult of art nor with simplified antiart gestures. In different ways both men used objective description as a screen for the pursuit of their art.

What do Lichtenstein's appropriated images mean? Do mass-produced comic strips and individually formed easel paintings have the same meaning? Obviously not, no matter how closely a source seems to be followed, and it was the error of early critics not to see this. Is the quoted and adjusted single frame of a comic ennobled by the fine artist's peculiar attention? This is not how a member of the rationalistic generation of artists after Abstract Expressionism would see it. Lichtenstein emphasizes the fact that what we see is only one of a number of possibilities. Instead of painting being identified with the ultimate configuration, its form is optional. Thus Lichtenstein has full control over the state of the image (see Notes on Technique), but is not bound to make absolute claims for what he does. The zone of human decision and experience is stressed, not a quasi-platonic sphere of inevitable form. Readers who have visited artists' studios will know how common the resort to inevitability is; it blocks dissent and confirms an artist's sense of possessing special insight. Pop art in general and Lichtenstein in particular opposed this form of artistic self-enhancement by insisting on the common basis of their forms. Quotidian imagery, shown crossing from life into art, gives familiarity a hard polemic value as it inserts art into the present without the traditional evocation of art as out of time.

Quotation in Pop art preserves its topicality, but not its source significance. Can the change from first to second usage be described as continuous, like the transformation of Dr. Jekyll into Mr. Hyde? Only apparently. The audience for the comics is not the same as that for Lichtenstein's complex paraphrases: the conditions of viewing are antithetical and the distribution patterns divergent. And yet Lichtenstein succeeded in persuading a large part of his early audience that he was passive before his models. Twenty years later the problem is reversed: how to remind a later generation that these well-organized paintings included, as part of the sting of the new, a mask of subversive acquiescence.

31. *Nurse*, 1964
Magna on canvas, 48 x 48 in.
Hessisches Landesmuseum, Darmstadt
Sammlung Karl Ströher

32. *Frightened Girl*, 1964
Oil on canvas, 48 x 48 in.
Irving Blum, New York

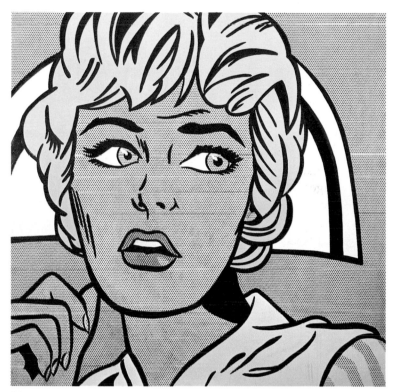

31

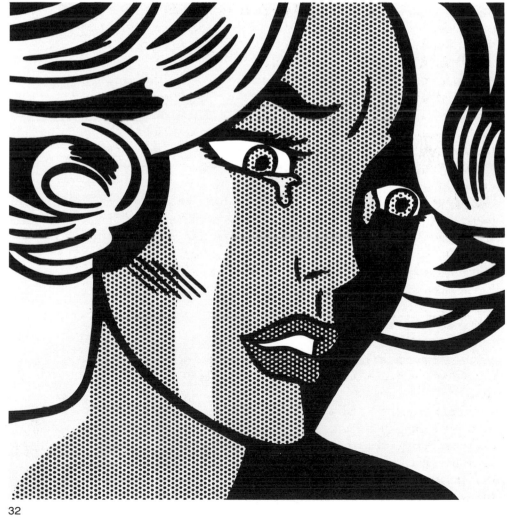

32

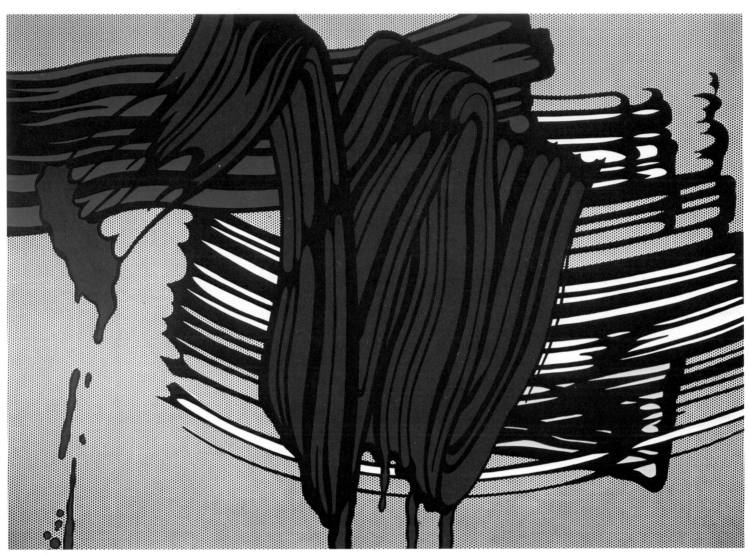

33

3 Art as a Topic

34

33. *Big Painting VI*, 1965
Oil and Magna on canvas, 92½ x 129 in.
Kunstsammlung Nordrhein-Westfalen,
Düsseldorf

34. *Non-Objective I*, 1964
Magna on canvas, 56 x 48 in.
Hessisches Landesmuseum, Darmstadt
Sammlung Karl Ströher

Lichtenstein staked out art as a theme in 1962 in terms of reproductions of masterpieces by Cézanne, Mondrian, and Picasso. The theme reappears in another form in the Brushstrokes of 1965–66: no specific artist is identifiable with them, but at the time the paintings were usually interpreted as a putdown of gestural Abstract Expressionism (the disparity between Lichtenstein's neat technique and the hefty swipes of impasted paint is marked). Lichtenstein made the point that his own early work included an Abstract Expressionist phase, but the notion of generational hostility persisted. These works, allusive but non-specific, were followed by the Modern paintings of 1966–67—paraphrases of Art Deco, stylistically unmistakable but also carrying few readable quotations of particular works or artists. Thus, the idea of style that had grown up to unify the various cases of specific reference in the comics paintings turned out to be compatible with subjects derived from art and design.

Both of the later groups are derived from art, but with considerable ironies in the transfer to painting. The Brushstrokes were painted at a time when the gestural aspect of abstract painting had been overtaken by less demonstrative modes, with which critics often identified Lichtenstein himself. He was linked largely with Frank Stella for his cool attitude and with Kenneth Noland for his calm touch. The Modern paintings take geometric ornament from architecture and design and convert it to the surface of painting. His sources included American and European design magazines and books like *52 Ways to Modernize Main Street with Glass* (a promotional publication for Vitrolite, an opaque structural glass). Incidentally, Lichtenstein was using these forms before *Art Deco* had been revived as the term for these period geometrics, a reminder of his prescience. He replaced the ambiguous or false expressionism of the Brushstrokes with a nostalgic order, neither of which is a securely based value. Both, in fact, are examples of Lichtenstein's fascination with "discredited values," with devalued meaning.

In the early 1960s the paintings from the comics had the look of

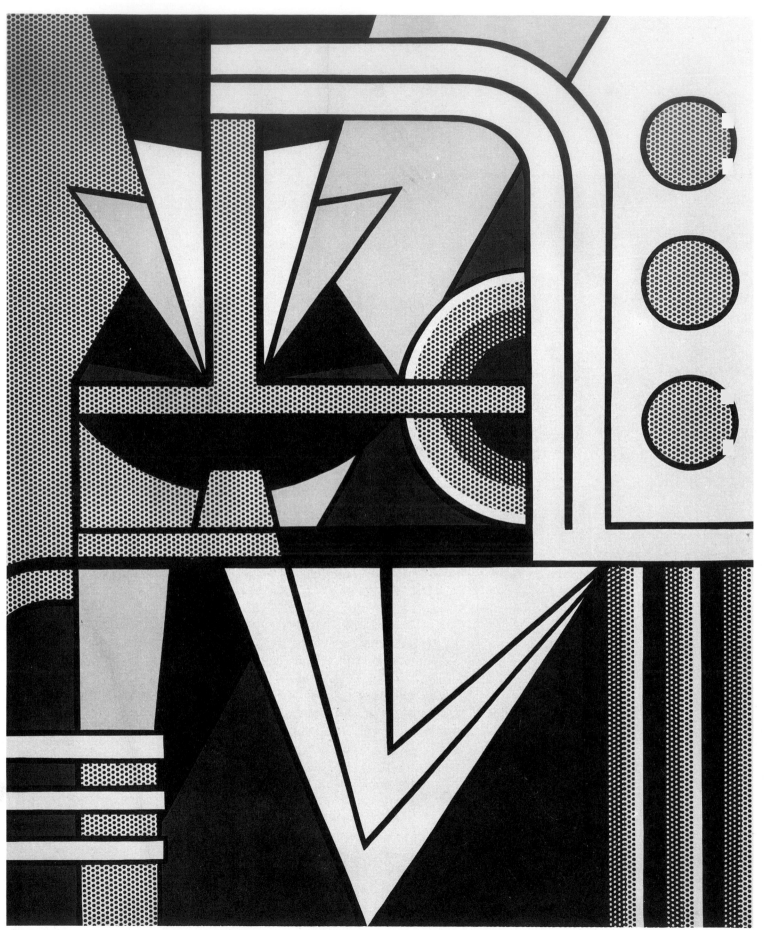

35

36

antiart, with the complexities of easel painting apparently suspended in favor of the formulas of popular culture, and the single-image paintings seemed brutally restricted by their resemblance to the Ready-made. These were followed by the paintings dealing with the theme of art, big and powerful works that kept Lichtenstein's characteristic double-takes. One or two Brushstroke paintings have details of hand and brush in the margin, but the characteristic form of the series is that of the newly invented brushstrokes alone, sometimes singly, sometimes overlapping. Whether isolated or enmeshed they have a rubbery consistency that implies high ridges of impasted paint, squelching out into occasional drips and spatters. The way in which Lichtenstein uses his meticulous technique to simulate a gestural process is ironic in the same way as cartoonists' explosions, a marriage of the quick and the slow. The directional thrust of the gestural marks is coolly indicated, from rounded full beginning to a ragged conclusion after a progressive fraying as the paint thins out. All of the paint tracks, the single images and the multiple overlapping ones, occupy imperturbable fields of benday dots, usually larger than in the earlier paintings. These works are followed by the Modern paintings; in some ways they are unlike one another, but in other ways they are linked. The free-form irregularity of the one turns into the geometric regularity of the other.

In the Modern paintings an inventory of zips, circle sections,

35. *Modern Painting I*, 1967
Oil and Magna on canvas, 80 x 68 in.
Private collection

36. *Modular Painting with Four Panels*, 1969
Oil and Magna on canvas, four panels,
54 x 54 in. each
Wallraf-Richartz Museum, Cologne
The Ludwig Collection

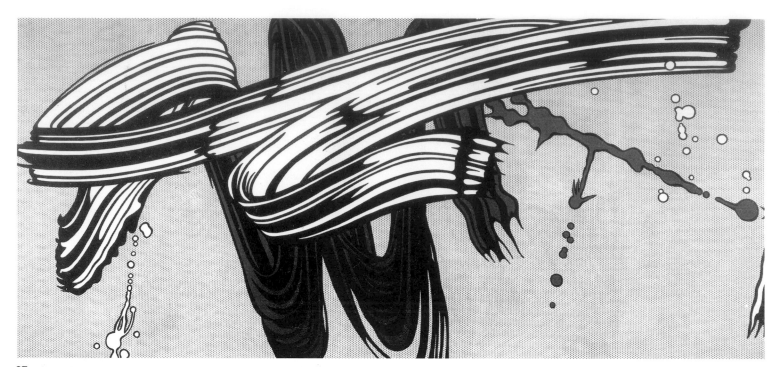

37

and triangles, of volutes, stepped forms, and portholes, often in threes, creates a subdivided and layered space, but one firmly based on the rectangularity of the canvas. These paintings take the populist, commercial style of the 1930s—the Art Deco of ocean liners, theater foyers, and enameled jewelry—as a source of form in opposition to the simplifying lines of more respected design. Lichtenstein has linked these works to Minimal sculpture,[7] but they are its opposite: this is Radio City Music Hall, not the Bauhaus. Right-angled but garrulous, abstract but frantically playful, these paintings catch without qualms the heavy design sense of the period. These tightly locked geometrics were, as the artist has pointed out, originally emblems of the future. However, enough time has passed for us to be overwhelmed by a sense of these forms' remoteness. There is a poignant sense of time as we look at the symbolic geometry that derives from a decade in which, to quote Lichtenstein, "they felt they were much more modern than we feel we are now."[8] Thus he is neither nostalgic nor camp, but dealing with human experience in time, as the title of the series, Modern paintings, signals.

The custom of associating art with lofty meaning, an inheritance from nineteenth-century aesthetics perpetuated both by the specialization of art and the ambition of its supporters, reached a climax in the 1950s. The work of art was affiliated with a vague but exalted state, the immediate source of which was Abstract Expressionism. Lichtenstein and other artists of the subsequent generation, born in the 1920s rather than before World War I, resisted it; their problem was to produce art without metaphysical sanction. Timelessness was contrasted to topicality, otherworldli-

37. *Yellow and Green Brushstrokes*, 1966
Oil and Magna on canvas, 84 x 180 in.
Hessisches Landesmuseum, Darmstadt
Sammlung Karl Ströher

38. Installation view, Leo Castelli Gallery, 1965.

39. *Yellow and Red Brushstrokes*, 1966
Oil and Magna on canvas, 68 x 80 in.
Private collection, Paris

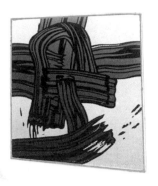
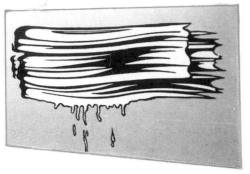

38

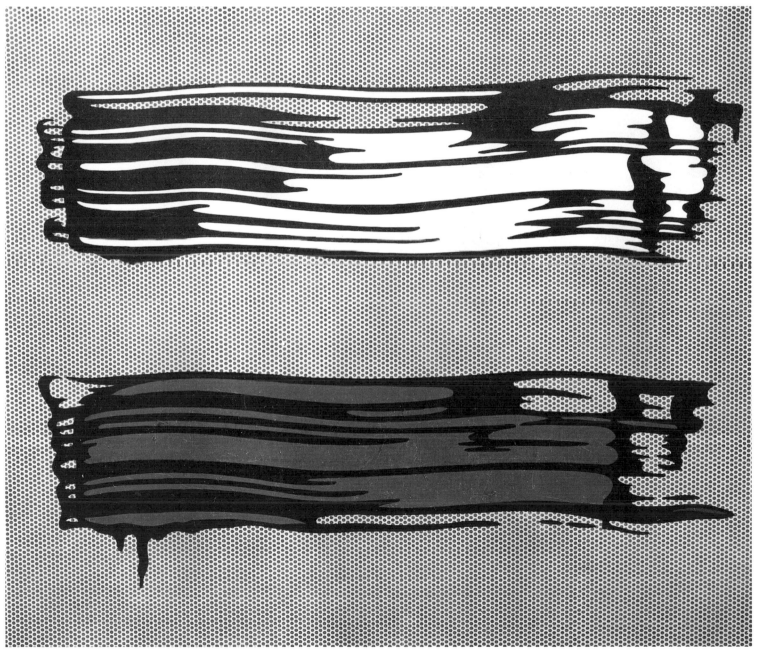

39

41

ness to quotidian life. Afterward, Pop art was criticized for its lack of political content, but in fact its insistence on art's immediacy in time and dailiness of subject matter ("things the mind already knows"[9]) was implicitly political. Certainly it was a large step toward the politicized art that was to reject it for not being sufficiently sensitive to current issues. The absence of specific references to causes that subsequently became urgent is not evidence of social indifference. Pop artists rejected the notion of a "tragic and timeless" art, in Rothko's phrase. They introduced current events and objects encoded in forms that were already flat: the flatness of Pop art therefore constitutes a shift in values away from the aestheticization and upward philosophical mobility of their predecessors. Lichtenstein's interest in discredited areas is a reaction against sentimental overestimations of the artist's role and a recall to order of flighty aesthetics.

There are two theories of Pop art and Lichtenstein is central to both of them. There is (1) a narrow definition that restricts Pop art's sources to mass-produced items like Lichtenstein's comics or Warhol's Campbell's soup cans and (2) a broad definition that assumes a spectrum of preexisting artifacts and signs as subject, including but not restricted to consumer goods. Those who stress Lichtenstein's and Warhol's prominence contract the range of signifying functions that Pop art represents. The narrow grouping, to which Tom Wesselmann is also assigned, proposes an art that deals with commercial imagery in a bright, planar style relatable to contemporaneous hard-edge painting. In fact, it is this work that supports the frequent comparison of Pop artists to Ellsworth Kelly and Frank Stella. Not only does this definition leave out Jim Dine, Claes Oldenburg, and James Rosenquist, because they are not flat and linear in their work, but it also ignores the course of Lichtenstein's development.

The narrow view of Pop art eliminates Jasper Johns and Robert Rauschenberg, as well, because of their painterly facture and historical priority, but their experiments with signification seem compatible with the broad definition. Lichtenstein has recorded no debt to their work, but he has said that his awareness of the environment as a source of subject matter was stirred and sharpened by early performance art. "Happenings used more whole and more American subject matter than the Abstract Expressionists used,"[10] Lichtenstein said appreciatively. The incorporation of common objects and messages in art was practiced and proselytized by Allan Kaprow, whom Lichtenstein knew well. He was the advocate of an ambience-responsive rather than an ambience-exclusive art, such as non-denotative abstract painting. The formality of Lichtenstein's art is the result of a reconciliation between what the street gives and what the canvas proscribes. There is a tension between the two that has no analogy in the abstract painting with which Lichtenstein's work is so often compared, because abstract art does not evoke specific references. Lichtenstein has recorded that his taste in art criticism is for "unusual insights—things I haven't thought of. I think of them as inventive but not necessarily true. I mean, I'm sure my own insights are just as askew as anyone else's."[11] This notion of meaning as a variable is not far from

40. *Modern Painting with Clef*, 1967
Oil and Magna on canvas, 100 x 180 in.
Hirshhorn Museum and Sculpture Garden,
Smithsonian Institution, Washington, D.C.

41. *Peace through Chemistry*, 1970
Oil and Magna on canvas, three panels,
100 x 60 in. each
Private collection

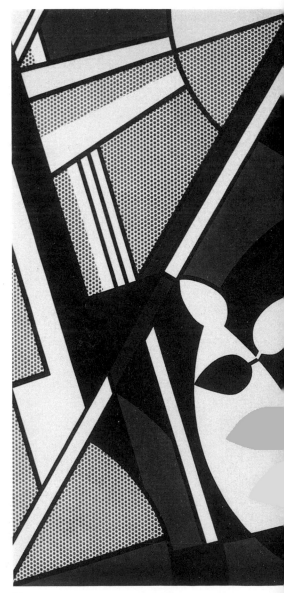

41

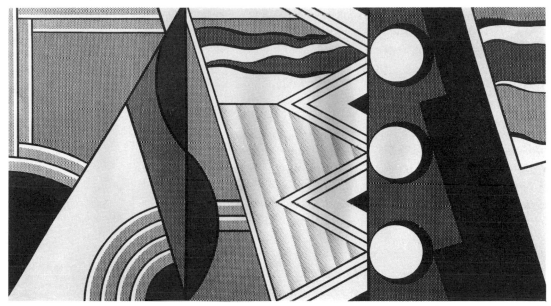

40

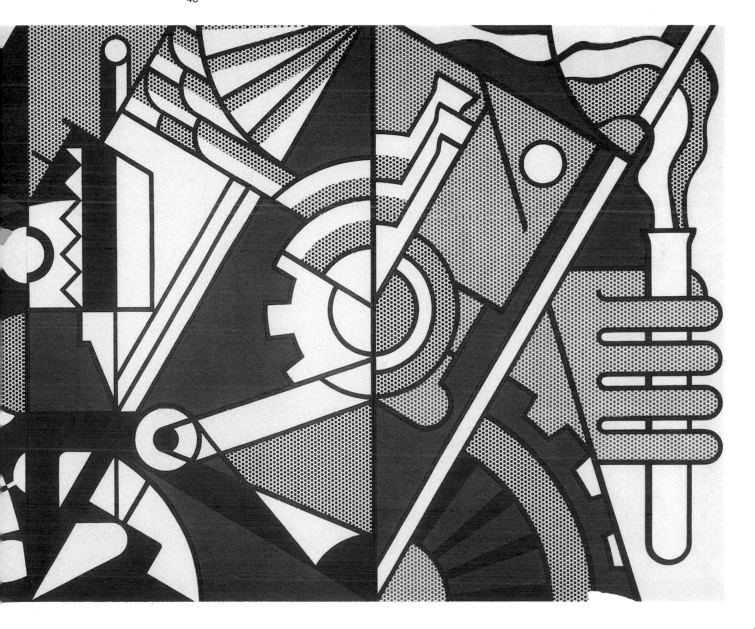

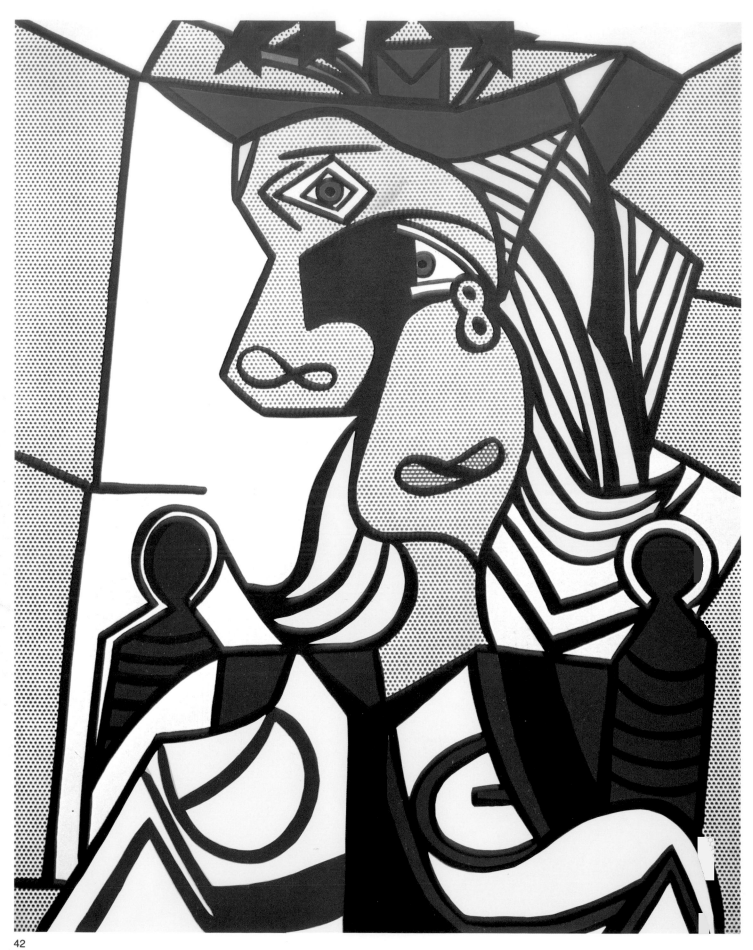

42

43

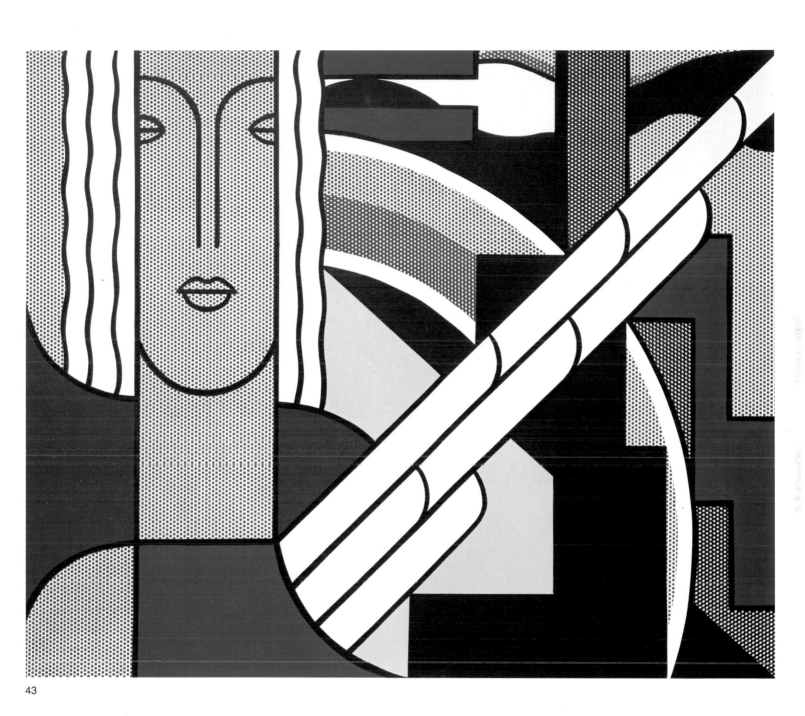

42. *Woman with Flowered Hat*, 1963
Magna on canvas, 50 x 40 in.
Private collection

43. *Modern Painting with Classic Head*, 1967
Oil and Magna on canvas, 68 x 82 in.
Irving Blum, New York

Johns's view that the meaning of a work of art depends on its use. For an artist to have a non-proprietary attitude to meaning derives from both Marcel Duchamp, Johns's model, and from the impacted communications of our society as they continually demonstrate ambiguity.

Lichtenstein's references to fine art are a logical though unexpected extension of popular culture. First, the Cézanne references, filtered through Erle Loran's compositional diagrams: Lichtenstein was attracted by the paradox of an art of no contours, or at least very complex ones, being presented in schematic form. These schemata of Cézanne's art unintentionally resembled the comics, and Lichtenstein played with this fact. Loran tried to sue the artist for his use of the outlines, but unsuccessfully: the courts may not have put it this way, but essentially the notion of a continuum of information prevailed over the notion of a world held hostage to copyright.

The second artist quoted was Picasso, whose paintings of the 1940s were already diagrammatic in their graphic clarity. Lichtenstein took the paintings from reproductions and represented areas in benday dots, making visible the means of Picasso's popularization through multiple reproductions. This was not a simple putdown, though there is an edge to it: Lichtenstein has spoken of his admiration for the graphic quality of Picasso and other twentieth-century artists. Picasso, no less than Joan Miró or Mondrian, was producing an art amenable to "mechanical reproduction" (Walter Benjamin's phrase), though this is not what is usually considered when their art is discussed. Picasso quoted famous works by Manet and Velázquez, for instance, but this is not what Lichtenstein does. He takes routine Picassos and shows how well they fit into the culture of reproductions. It was not a personal possessive act, like Picasso's, but a critical and questioning one. Lichtenstein is calling upon our experience of books by Skira and Harry Abrams and all that lies between. In 1974 Lichtenstein made several paintings after Mondrian, which take as subject that artist's standardized means and high visibility. Incidentally, it was around this time that Yves Saint-Laurent made his line of mass-produced Mondrianesque dresses—urban, youthful, rather straight cut. Apparently the designer's mother had given him a book on Mondrian as a present, from which this pop culture tangle of art, replication, and life emerged.

Lichtenstein observed that "There is a relationship between cartooning and people like Miró and Picasso which may not be understood by the cartoonist, but it definitely is related even in the early Disney."[12] It may not have been understood by Miró and Picasso either, occupied as they were by notions of fine art. Lichtenstein is proposing a two-way relationship between cartoonists and fine artists, in which graphic condensation is common to both ends of the spectrum of taste. However, this does not mean that Lichtenstein thinks that anything goes. "I really don't think that art can be gross and over-simplified and remain art. I mean, it must have some subtleties, and it must yield to aesthetic unity, otherwise it's not art."[13] The subtleties do not have to be obvious, so to say, but given the tactics of his art they must be consistent. The artist

44

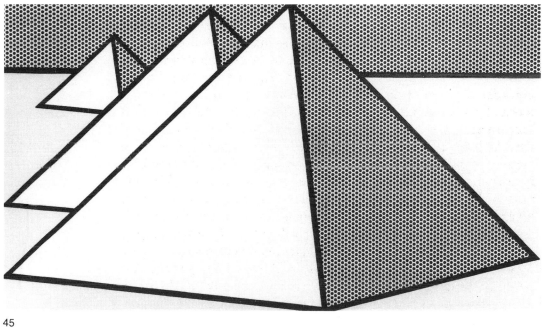

45

44. *Pyramid Sketch*, 1969
Pencil and colored pencil on paper,
19¾ x 25 in.
Private collection

45. Study for *The Great Pyramid*, 1969
Oil and Magna on canvas, 43 x 68 in.
Courtesy Galerie Beyeler, Basel

explained his blown-up benday dots as meaning "reproduced material, but I think they also may mean the image is ersatz or fake. . . . The dots indicate a fake brushstroke in my brushstroke paintings. In this case, it means fake 20s or 30s."[14] This sense of the pleasure taken in substitutions and double-takes can be indicated by other quotations from the artist: "I'm trying to make a commercialized Picasso or Mondrian"[15] and the Cathedrals are described as "like a quick, cheap Impressionism."[16] These terms suggest not the simplification of which Lichtenstein was accused or at least suspected, but a more complex situation.

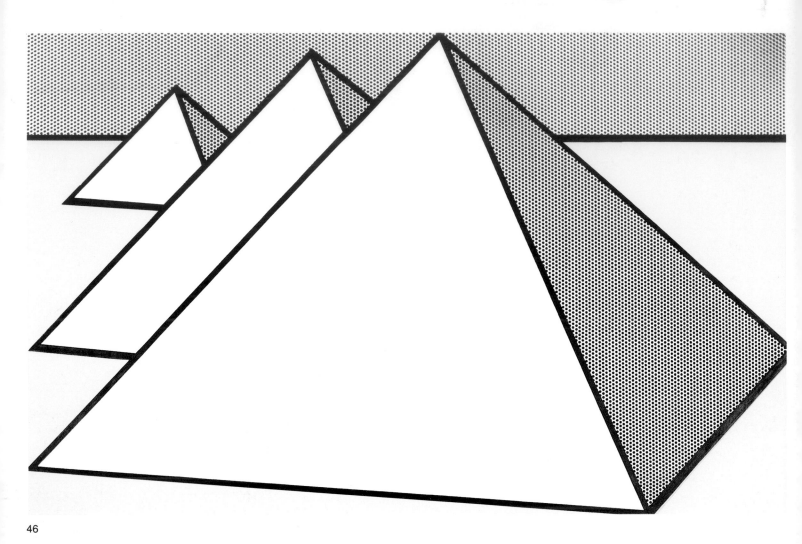

46

The train of thought that took Lichtenstein to Picasso and Mondrian from the comics led to a further expansion of his iconography: his Architectural Monuments (1964–69). It is as if memories of Art History 101, or whatever the college survey class is numbered, provided ready-made images of Greek temples, Egyptian pyramids, and French Gothic cathedrals. Lichtenstein also evokes tourism, the postwar activity that has perhaps not so much enlarged the world as condensed it into a scatter of separated places. In a sense, academics and travel agents have reinforced one another in the schematization of time and space, respectively. Lichtenstein draws on this unacknowledged and slightly disreputable collaboration for his shining, banal images. He has recorded[17] that a repeating stencil of the Pantheon in a Greek restaurant in New York gave him the idea of tackling classicism. In the event, after trying stencils, he ended up painting the temple in a version of the comics style.

The Monuments connect with his earlier style, but there are differences. The artist is in absolute command, conceptually and manually, of the process of work, with the result that anything tentative is effaced, nothing improvised can be seen. The wonders of the world are presented in the hardest, least inflected coding

46. *The Great Pyramid*, 1969
Oil and Magna on canvas, 129 x 204¼ in.
Des Moines Art Center, Iowa
Coffin Fine Arts Trust Fund, 1970

47. *Temple of Apollo*, 1964
Oil and Magna on canvas, 94 x 128 in.
Private collection

system that Lichtenstein had used (pyramid as golf ball). Antiquity or history on one hand and the image of mechanized process on the other are bound together, which is precisely the kind of effect that Lichtenstein enjoys. The benday dots are larger than before; they are a small but continuous surface, and hence more exactly manipulable in relation to the planes of solid color. Contours are even and clear, apparently unmodulated, but Lichtenstein does not use tape, so they are drawn. The act of drawing is thus preserved at the core of these paintings, but covertly.

The Temples and Pyramids, reduced to a bare minimum of contour and color, have something of the visual clout of the single-image paintings, though of course same-size representation or enlargement of the objects no longer occurs. Lichtenstein, however, maintains a comparable inch-by-inch grip on the surface of the pictures, so that the visual configuration is insistently depicted. The Temple of Apollo (1964) looms like a nuclear submarine in a 47 misty harbor, seen as it is against a two-phase landscape, blue dots on white for the sky, white on blue for the mountains, the two

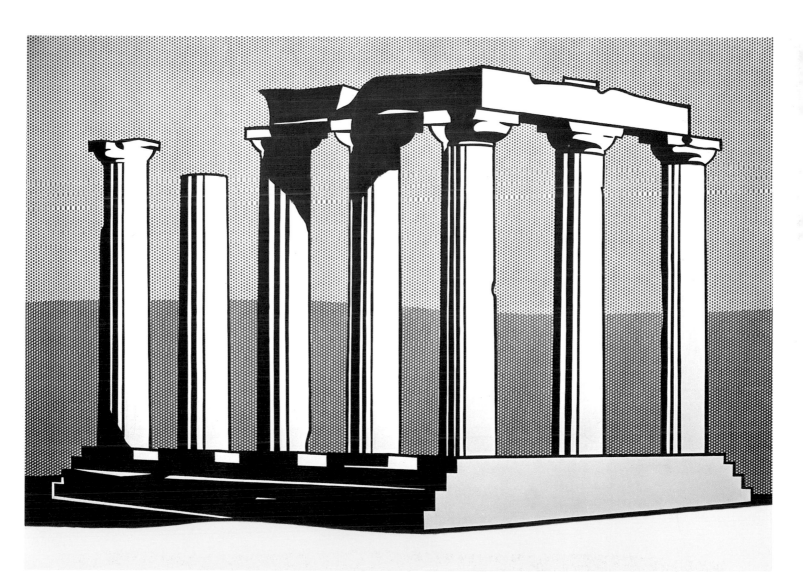

49

48. *Seascape II*, 1964
Oil and Magna on canvas, 48 x 56 in.
Private collection, Paris

49. *White Cloud*, 1964
Oil and Magna on canvas, 68 x 80 in.
Irving Blum, New York

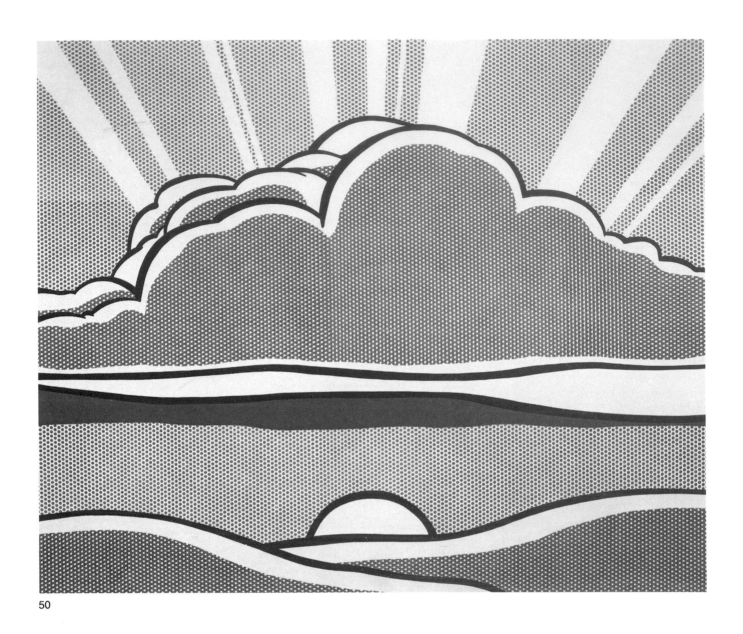

50

zones separated by an undulant horizon. The background recalls
the format of some of the Landscapes that Lichtenstein painted at
this time.

The Landscapes are a good example of the use of generalized
references, that is to say, references to a style or a mode rather
than to a specific original, as in the case of *Takka Takka*, for
example. The motifs of sunrise and sunset are pervasive in anony-
mous Art Deco design, the big expanding beams radiating from
the fat, low sun, the curved form of clouds in contrast to the
geometry of light. The succession of landscape and cloud levels
makes wavy strata that Lichtenstein establishes in terms of large
48 areas of expansive color. Some of the Landscapes, like *Seascape
II* (1964), make nonchalant allusions to coloristic field painting,
50 but the majority, like *Sinking Sun* (1964), evoke the preconscious
mélange of recent decorative art, still a thick residue in the suburban
environment. The Landscapes and Monuments combine Lichten-
stein's abiding concern with cliché, in relation to the time-binding

50. *Sinking Sun*, 1964
Oil and Magna on canvas, 68 x 80 in.
Private collection

51. *George Washington*, 1962
Oil on canvas, 51 x 38 in.
Jean Christophe Castelli, New York

property of art, the presence of the past in the present, with his increasing interest in color and unified imagery. The fact that these different preoccupations are balanced unobtrusively is typical of Lichtenstein's self-evaluative but reserved demeanor.

The Temples and Pyramids depict high monuments by means of low quotations—wall stencils and a postcard in the case of the *Temple of Apollo* and a similar schematization of the pyramids. They are the equivalent of, say, the *George Washington* of 1962, 51 which comes from Gilbert Stuart's portrait via a woodcut in an ethnic newspaper. The Rouen Cathedral paintings (1969), in sev- 52 eral groups of multiple views, differ: here one technique is being translated into another that is apparently incompatible with it. Monet's improvised and physically involved method of painting is shifted into an order like pointillism.

It is relevant to note another influence on Lichtenstein's Cathedral paintings that the artist has acknowledged: *Serial Imagery* by John Coplans.[18] Monet, of course, painted in series, and, in addition, Lichtenstein was interested in the paradox of a systematically executed Impressionism. Thus, image repetition, like the color screens used in reproduction, is joined to the physical fact of painting. Lichtenstein observed: "It's an industrial way of making Impressionism—or something like it—by a machinelike technique. But it probably takes me ten times as long to do one of the Cathedral or Haystack paintings as it took Monet to do his."[19] This is perhaps the most extravagant example of Lichtenstein's veiling of manual procedure behind the appearance of impersonality, of the simulated mechanization of technique that is actually a reserved form of high finish. It is secretive, in a sense, because his imperturbable surface is the outcome of an intensely realized standard of completion that absorbs traces of process the way a vacuum cleaner in a motel removes the dust of yesterday's occupant. Monet's original paintings are subjective records of sensibility, but Lichtenstein's version deals with the externalization of order as a mechanical and democratic mode, like color reproduction. Large, clear, graduated dots are intensified as pure color, without the customary black outlining to contain sections and to brace the whole. Here there is no linear scaffolding, but an allover color skin.

It is noticeable that from 1965 Lichtenstein's development tends to a step-by-step progression, rather than a continuous unfolding. There is no loss of cogently developed themes, but his development is carried by units larger than the single work. He paints sets of pictures with periodic shifts. Every couple of years or so these works appear publically in new one-artist exhibitions. At least since Monet's coordinated show of the Rouen Cathedral paintings in 1881 at Durand-Ruel's gallery in Paris, the production of artists and their rates of change have frequently followed the gallery schedule. (Earlier, the annual or biannual Salon exhibitions encouraged the production of single, competitive, knock-'em-dead history pictures.) It is a part of the professional drive of an artist like Lichtenstein to incorporate the conditions of distribution in the fact of production. The links and differences between the Brushstrokes and the Modern paintings show that his own ideas

51

52. *Rouen Cathedrals I, II, III, IV, V*, 1969
Oil and Magna on canvas, five panels,
63 x 42 in. each
Private collection

53

have not been inhibited by adaptation to the gallery schedule. The Mirrors (1970–72), the Entablatures (1971–76), the so-called Surrealist paintings (1977–79), and the American Indian paintings (1979) have a comparable compactness. Lichtenstein has successfully combined the momentum of personal development with the episodic nature of regular renewal. Picasso was the twentieth-century artist who established this accommodation with the gallery system, in which the first-person authority of the artist coincides with the program of exhibitions and is authenticated by its pace.

Lichtenstein's sculpture also occurs in bunches, not formally continuous with each other but derived from his paintings. In 1965 there was a group of Explosions, freestanding and in relief. The comics-derived image of the catastrophic release of energy that he had painted earlier in such works as *Whaam*! and *Va-room*! is solidified in enameled steel. It is not the suddenness, briefness, or force that he wants to convey: from their thorny centers, wagon-wheel spokes of fire and concentric planes radiate outward in ironic fixity. (To the extent that they are like big jewels or ornaments, they anticipate the Modern paintings of a couple of years later.) In the same year Lichtenstein used glazed ceramic to make cups and saucers (artistic material and the substance of the

53. *Haystack*, 1969
Oil and Magna on canvas, 16 x 24 in.
Private collection

54. *Haystack*, 1968
Oil and Magna on canvas, 18 x 24 in.
Private collection

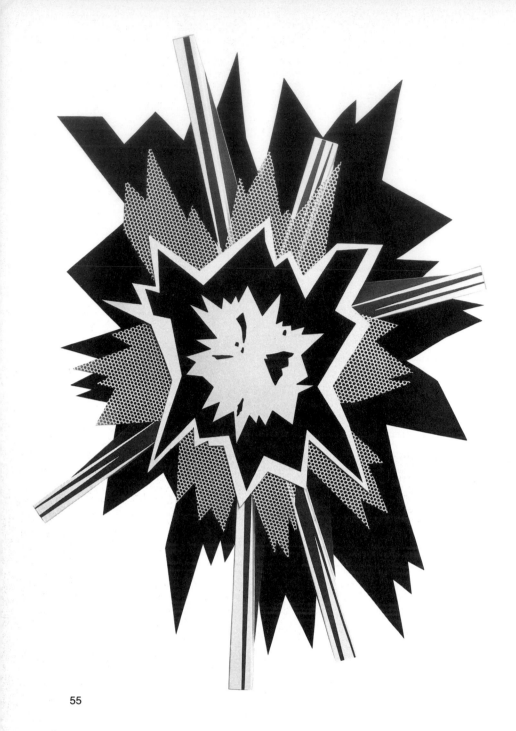

55

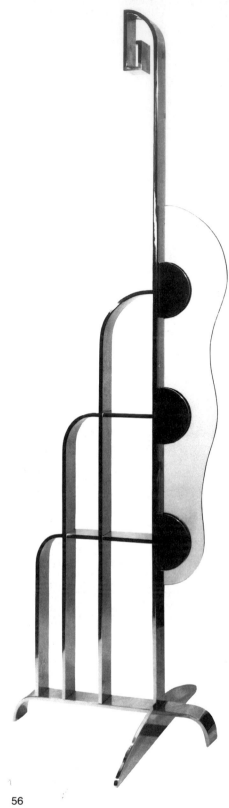

56

depicted objects being the same) and women's heads. Planes of color and patches of benday dots stretch around the curved surfaces, but do not lighten the blunt, thick-rimmed effect. In 1967–68 Lichtenstein made his most successful group of sculptures, the Modern sculptures, in which elements are derived from the leisure architecture of the 1930s: the railings of ocean liners, the thresholds of theaters, the bars of hotels. Without acting as physical obstacles or delays, there is a sense of lines, that is queues, in these 57 pieces. In *Modern Sculpture with Velvet Rope* (1968), the polished brass sections make a kind of gate, closed by a plump velvet rope like a nostalgic souvenir of movie foyers. Typical materials are brass and marble, aluminum and black glass, brass and mirror.

The next group of sculptures, begun ten years later, are mostly painted bronze; elements from his still-life paintings, such as the goldfish bowl, are both enlarged and given a third dimension.

55. *Explosion II*, 1965
Enamel on steel, 88 x 60 in.
Hessisches Landesmuseum, Darmstadt
Sammlung Karl Ströher

56. *Modern Sculpture with Glass Wave*, 1967
Brass and glass, 91 x 26 x 27 in.
Edition of three

57. *Modern Sculpture with Velvet Rope*, 1968
Brass and velvet rope, two sections, 83¼ x 26 x 15 in. and 59 x 26 x 15 in.
Edition of three

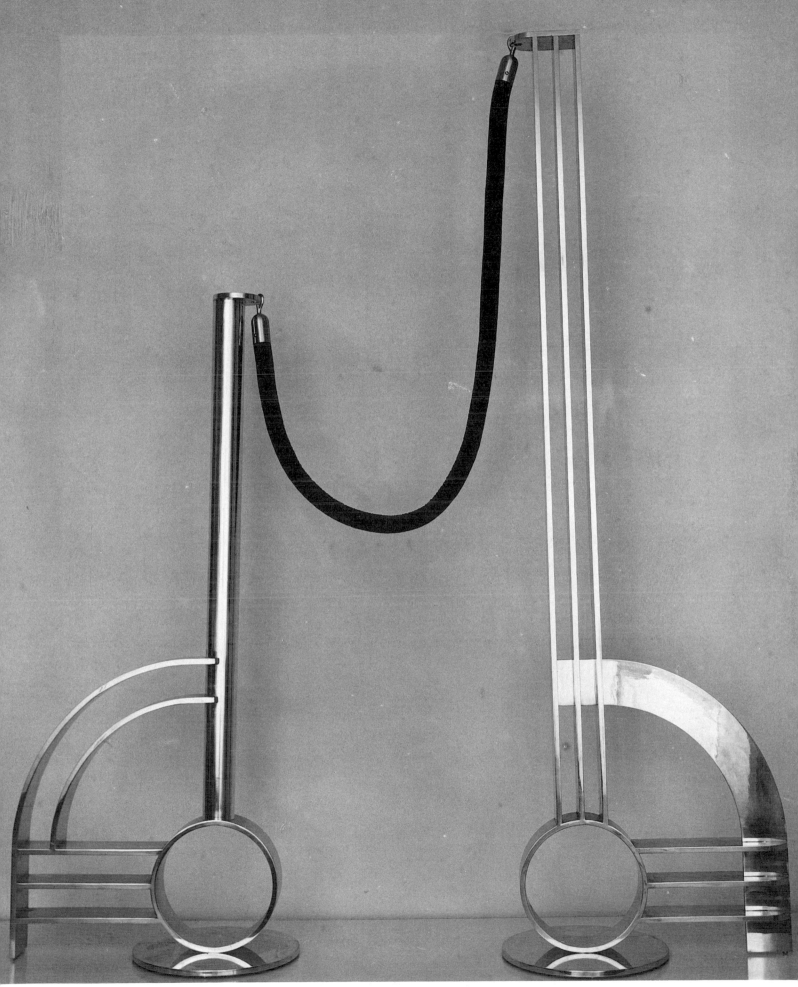

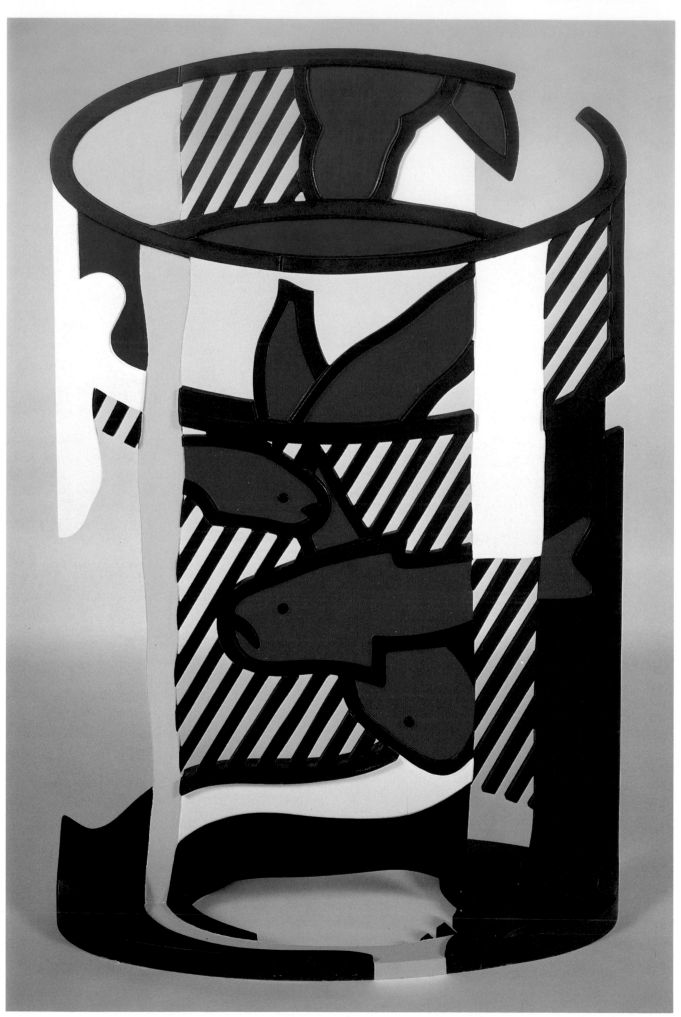

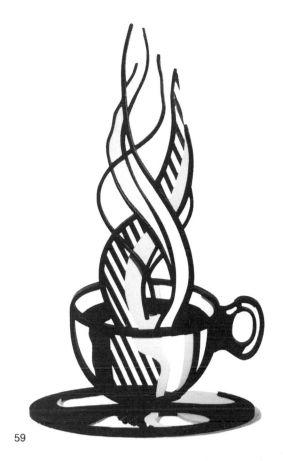

59

There are abrupt jumps between positive form and negative space, contours and voids. Two- and three-dimensional space are shuffled to desubstantialize the rigid material and its location in space. The obdurate is assigned to shifting appearances.

Each group of Lichtenstein's sculpture is distinctive and unlike the others, both materially and formally. A common attitude toward sculpture does emerge, however: his is anti-sculptural sculpture in its malice toward three dimensionality. In the still lifes, for instance, polychrome is used to fragment volumetric clarity, and by taking the Modern sculptures toward architecture, he brings them close to disappearance in the environment. Thus the games of reference that animate Lichtenstein's paintings occur equally in his sculpture.

By affiliating his sculpture to his contemporaneous paintings, Lichtenstein separates the work from the materiality of sculpture. His pieces are pictorial, in source and function. This is in opposition to the aesthetics of artists who use either massive or repetitive forms (like Mark di Suvero or Carl Andre, for instance). The ingenuity of Lichtenstein's transitions between two and three dimensions is the opposite of bulky or regulated forms. It is the equivalent of the skill with which the artist moves from one material to another in each of his enclaves of sculpture. He demonstrates the mobility of images as they lodge in one medium or another and are not locked into one more than another. This, of course, goes against theories of the exclusivity of each artistic medium. Thus exchanges between painting and sculpture, as between architecture and sculpture, replace the criterion of medium uniqueness with a cross-media iconography. It is as if, every few years, Lichtenstein declares a common center for painting and sculpture.

58. *Goldfish Bowl II*, 1978
Painted bronze, 29 x 25¼ x 11¼ in.
Edition of three

59. *Cup and Saucer II*, 1977
Painted bronze, 43¾ x 25¾ x 10 in.
Edition of three

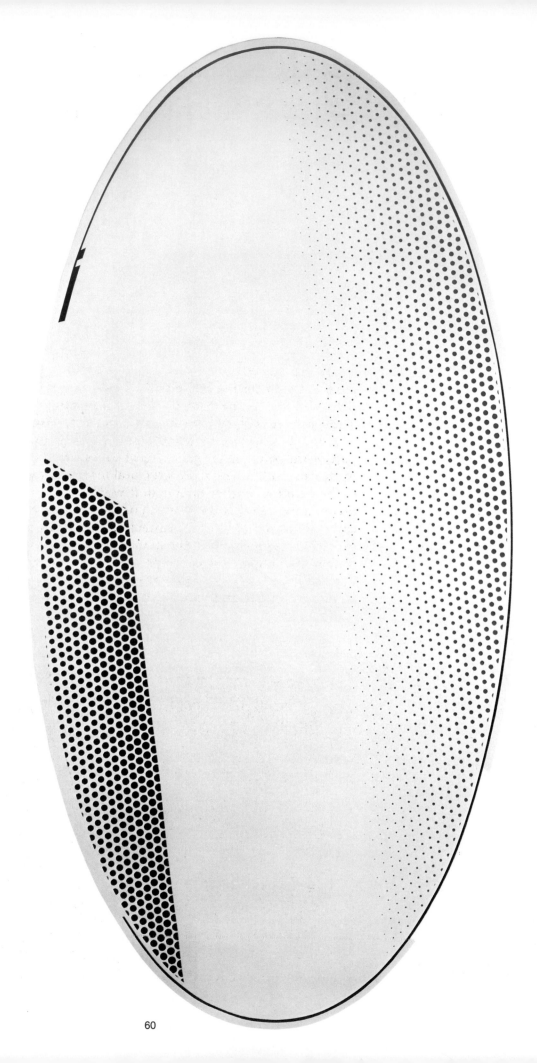

 # Mirrors and Entablatures

How did Lichtenstein arrive at the Mirror paintings? The unified field of color in the Rouen Cathedral paintings was one step. Though there is black in many, perhaps most, of the Mirrors, it is not used as drawing, to define edges or outline forms. Black is a part of the total planar game, equal to yellow or green or to the white canvas. It has no more structural function than anything else in the painting. Earlier than that, it would seem that an essential preliminary step was the painting of monomorphic objects in the early 1960s, in which Lichtenstein set the terms of a stark but problematic simplicity. Closer in time are his paintings of stretcher frames of 1968, in which a traditional nineteenth-century trompe l'oeil subject, the back of the canvas, is shown on the face. These paintings are flat and frontal, deceptive and undeceptive simul-

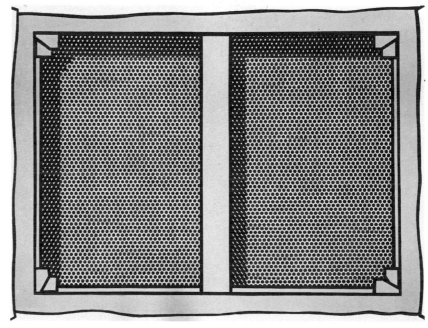

60. *Mirror #1*, 1971
Oil and Magna on canvas, 72 x 36 in.
Private collection

61. *Stretcher Frame with Vertical Bar*, 1968
Oil and Magna on canvas, 36 x 48 in.
Private collection

61

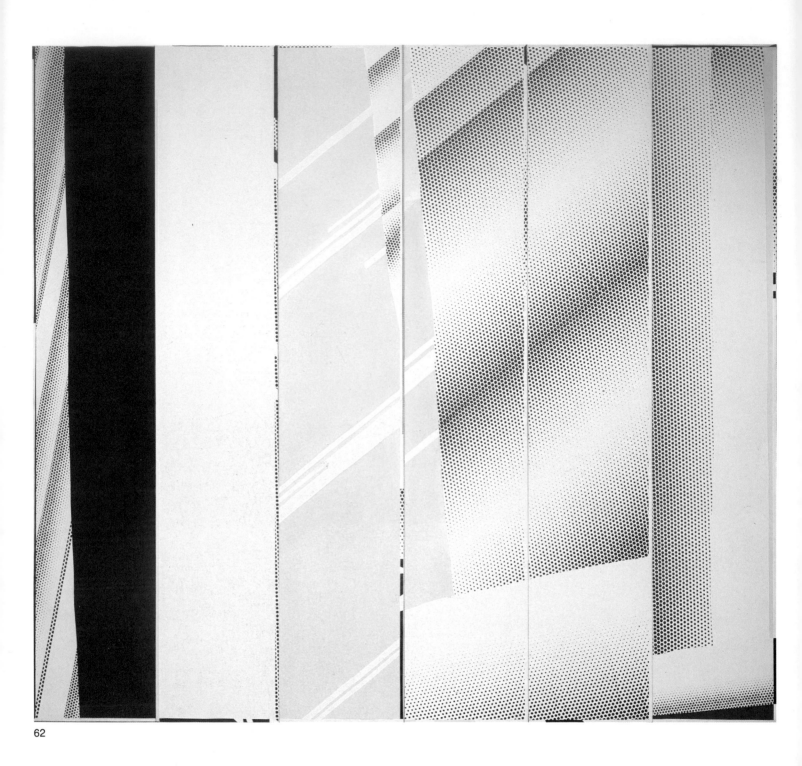

62

taneously. (That American trompe l'oeil was on his mind, if in a modified form, is clear from a group of subsequent paintings based on allusions to this style.) The illusion depends on the identity of format and subject in the stretcher frames, but the unyielding contours and emphatic black and yellow dots draw attention to the objectness of the work itself. This is not Lichtenstein at his subtlest, but the paintings lead to the unyielding but equivocal Mirrors.

The Mirrors—close to fifty of them, according to Jack Cowart, painted between 1970 and 1972—seem different from Pop art

62. *Mirror in Six Panels*, 1971
Oil and Magna on canvas, 120 x 132 in.
Private collection

63. *Mirror in Four Panels #1*, 1971
Oil and Magna on canvas, 96 x 72 in.
Private collection

because they are "close to being total abstractions," as Elizabeth C. Baker wrote.[20] On the other hand, mirrors have an iconographical history in art, which is not entirely effaced by the absence of specific allusions. Mirrors have been used moralistically to symbolize the passing of time (young women reflected as hags, for example) and didactically to support painting's rivalry with sculpture, by showing views of the body not available to the painter's restricted single viewpoint. Velázquez's *Las Meninas* (1656) and Manet's *Bar at the Folies Bergère* (1883)—two celebrated enigmas in the history of art—depend on mirrors, and Picasso juggled reflections too, notably in *Girl before a Mirror* (1932). Jan van Eyck's Arnolfini portrait as well as Francesco Parmigianino's and Carel Fabritius's tondi that simulate convex mirrors are also in the background, inasmuch as Lichtenstein's first and various later Mirror paintings were circular, though he maintained a steely flatness. Lichtenstein declines to state openly these iconographical options, or that used by Robert Rauschenberg in several silkscreen paintings with reproductions of Velázquez's and Rubens's paint-

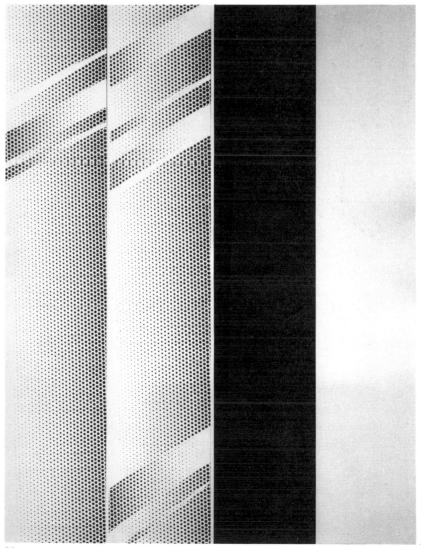

63

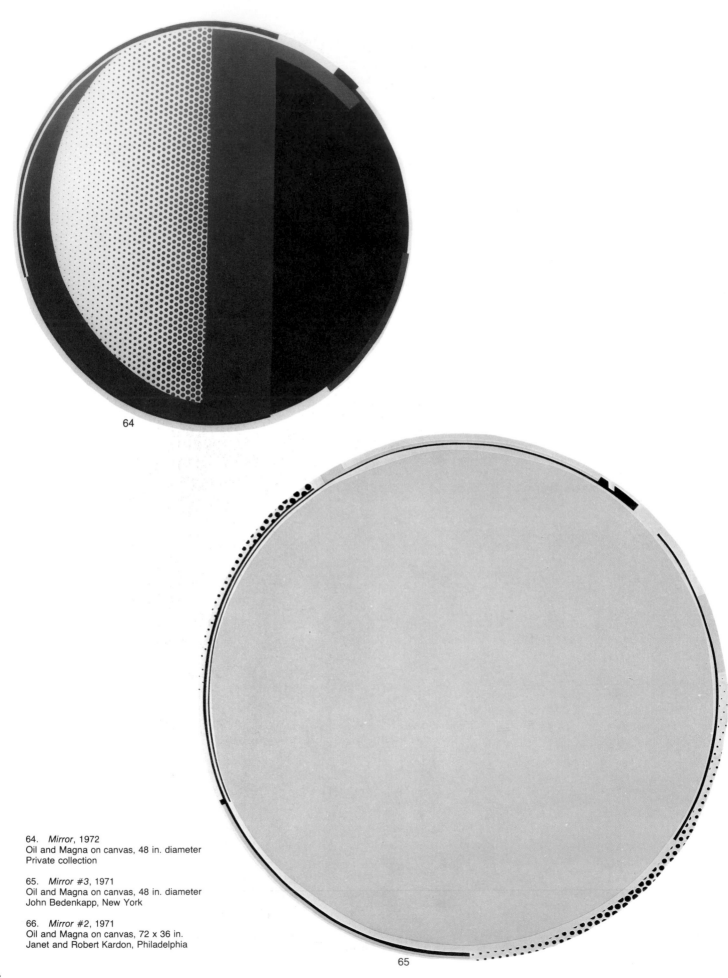

64

64. *Mirror*, 1972
Oil and Magna on canvas, 48 in. diameter
Private collection

65. *Mirror #3*, 1971
Oil and Magna on canvas, 48 in. diameter
John Bedenkapp, New York

66. *Mirror #2*, 1971
Oil and Magna on canvas, 72 x 36 in.
Janet and Robert Kardon, Philadelphia

65

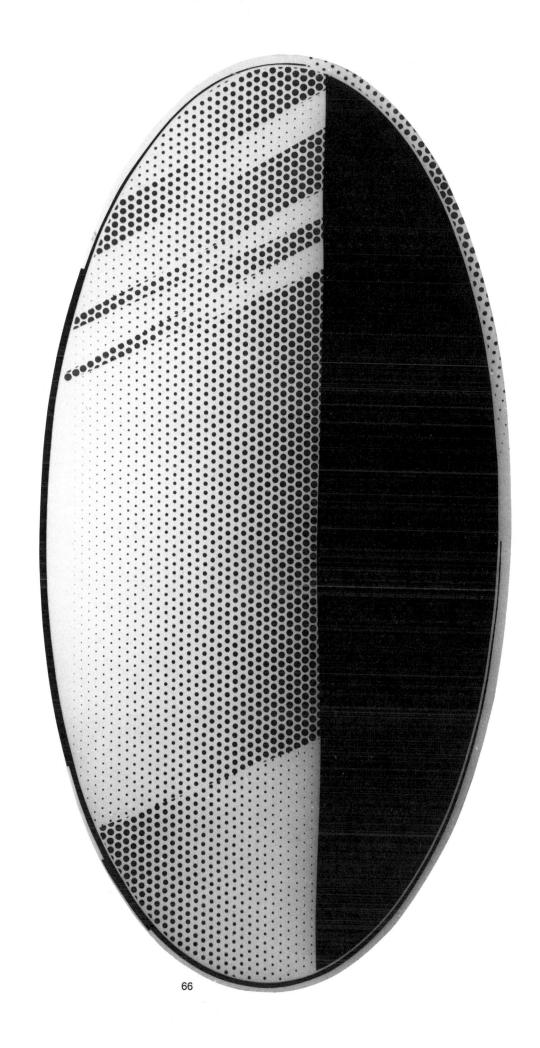

ings of Venus and Cupid, in both of which a mirror is held for the Goddess of Love by her son.

Lichtenstein identifies the complete surface of the canvas—circular, oval, or multipaneled—with the forms of mirrors. Thus the shaped canvas of abstract painting is turned into an ultimate act of imitation. The play of light on and in mirrors is arrested at a single state, which means that the paintings carry a doubt as to their relevance as signifiers during the very act of signifying. Taking newspaper ads and furniture store catalogs as a model, Lichtenstein uses screens of dots to indicate the smoothness of glass, parallel hatching to show the flash and zip of reflections, and jumps or notches at the edge to show the angled cuts of beveled edges. He has expanded these conventional signs into a brilliant game of references and denials. Since the mirrors are presented flat, that is frontally, we are made aware of the absence of our reflections even as we recognize the objects conceptually.

Overlapping the Mirrors is a group of paintings of Entablatures produced in two phases, ten in 1971–72 and twenty-eight in 1974–76 (again, according to Cowart). The Mirrors and Entablatures can be linked not only chronologically but also because they are both formal statements of high simplicity after the elaboration and compartmentalization of the preceding phase of Modern paintings. In the Entablatures, Lichtenstein takes an unprecedented subject for painting, that section of a classical temple above the columns that consists of (from upper to lower) cornice, frieze, and architrave. The cornice is the projecting top section, the frieze is the middle zone, and the architrave is the line of blocks immediately above the capitals of the column. (Cowart shows that Lichtenstein used photographs that he took of Wall Street and the 26th Street area—the street on which he had a studio in the 1960s—for his Entablatures.[21]) Lichtenstein's first group of these paintings

67. *Entablature #10*, 1971
Oil and Magna on canvas, 30 x 144 in.
Private collection

68. *Entablature*, 1976
Oil, Magna, metallic paint, and sand on canvas, 54 x 192 in.
Private collection

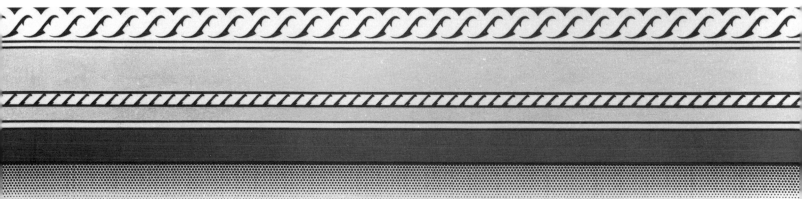

are long and thin, which is a physical analogue of the architecture; there is a wryly scenic aspect to the diagrammatic canvases as they stretch out horizontally.

Are Léger's still lifes of his Purist period a source of the Entablatures? Short bands of such classical ornament as egg and dart or bead and reel occur in the walls behind Léger's console tables and umbrella stands of the 1920s. Is he implying that mass-produced classical motifs are identified with the bourgeoisie and, if so, do they preserve their classical virtue in residual form or do they become trivialized? Léger is either using classical form as a source of precedent or an exhausted shell.

Of all our artifacts, the Greek temple is the most commonly accepted symbol of order, taking that word to mean the harmoni-

ous relation of parts to whole. Lichtenstein's Temples had already treated the paradigm as cliché, but the Entablatures are more insidious in their critique of classicism. There is an intervening stage between his paintings and their classical root, for elements of the entablature have provided decorative motifs for centuries of classicizing architectural ornament, with many of the derivations being perfunctory. Roger Fry, a formalist, a modernist, and a snob (an irresistible compound of attitudes to many critics still), sitting in a railroad waiting room made contemptuous notes on the democratic ornament that surrounded him. The room included "a moulding but an inch wide and yet creeping throughout its whole width a degenerate descendant of a Graeco-Roman carved guilloche pattern: this has evidently been cut out of the wood by machine."[22] (A guilloche is an ornamental band of interlaced curves.) Lichtenstein's Greek keys and dentils are subject to the same degeneration when repeated by machine production. He starts, as his photos show, with the mechanization of ornament as a fact, and includes it in his art, which is slyly hand-done.

The long, thin Entablatures are like several Jackson Pollock paintings of 1948–49 with such measurements as 2′9″ by 18′, 3′2″ by 15′9″ and 1′6″ by 9′. Thus there is implicit in the format reference to a modular and apparently mechanized form of Pollock's arabesques, a climax of the autographic touch. Lichtenstein's

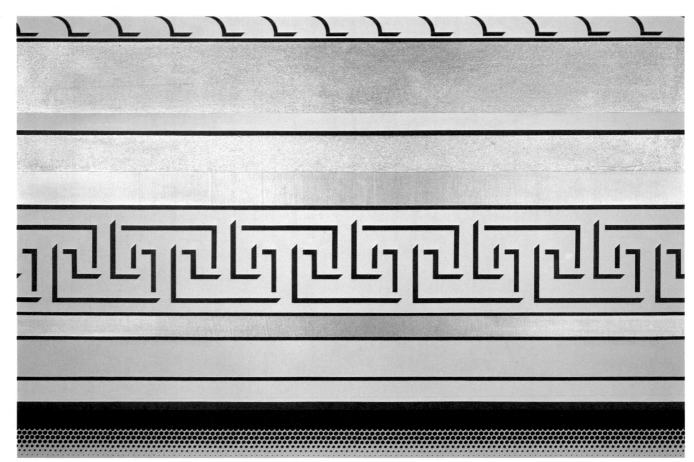

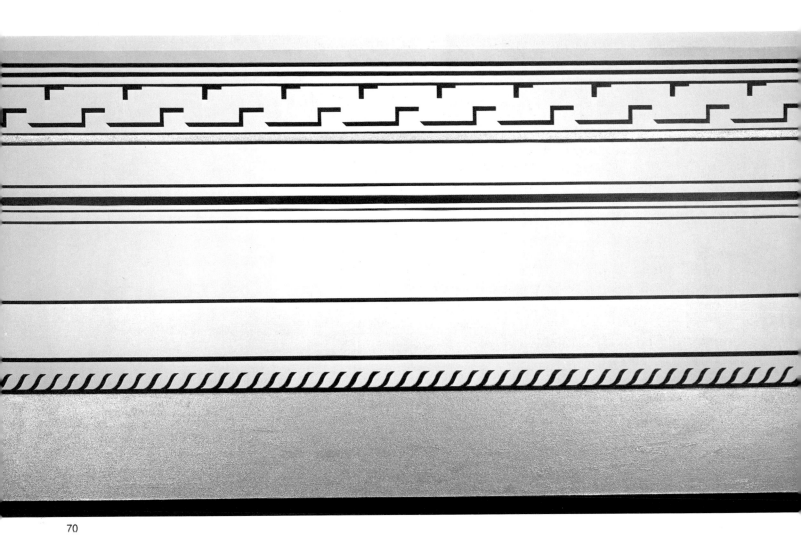

70

69. *Entablature*, 1975
Oil, Magna, and metallic paint on canvas,
60 x 90 in.
Private collection

70. *Entablature*, 1974
Oil, Magna, and metallic paint on canvas,
60 x 100 in.
Private collection

paintings are monochromatic: black paint on sparkling white canvas. These and the later Entablatures presuppose classicism in schematic form, like the artist's earlier quotation of Erle Loran's Cézanne. If we take classicism to be an optimum point of aesthetic control and completeness, schemata are antithetical to it. A diagram represents condensed information, the paraphrasing of something, not its unique embodiment. Lichtenstein's Entablatures of classical architecture subvert the idea of the order they display: they are denials no less than exemplifications.

In place of the rigor of the first paintings in the group, Lichtenstein devised a softer format for the second group. The canvases are conventionally rectangular and the bands of ornament are stacked vertically, sweetly colored, sometimes metallically tinted. (It is, let us say, Robert Adam compared to William Kent.) The solecistic stacking of motifs is reminiscent of the arbitrary on-site piling of newly recovered fragments at an archeological dig: the sandwiched strata supporting their Pompeiian complexion. The artist concedes to an "offhand" reference to Kenneth Noland[23] but it seems secondary to the play with classicism. However, we have the artist's word for it, so it is a reminder, if one were needed, that parody is one thread in Lichtenstein's allusiveness.

5 | Quotation

Given the fact that Lichtenstein was concerned with quotation and allusion, and with the interplay of high- and low-art references, how was he to paint them while preserving an interest, both formal and competitive, in abstract art? Obviously not in terms of allover painting with its low image-differentiation. He found what he needed, a way of painting that was neither abstract nor realist but connectable to both, in early Pop art. From abstract painting, a permeating educational factor for American artists at the time, he took flatness and centrality, not necessarily together; and realism he displaced into the form of his sensitivity to the urban environment and the rendering of objects in facsimile.

Although he was enthusiastic in his support of a "more whole and more American subject matter" in the Happenings, Lichtenstein's attitude toward subject matter in his own paintings has been reserved, even suspicious. Consider his statement that "once I have established what the subject is going to be, I am not interested in it anymore, although I want it to come through with the immediate impact of the comics."[24] This has been used to minimize the role of iconography in his art, but Lichtenstein's way of working gives his imagery a fixity that resists loss or alteration.

The connection to abstract art in Lichtenstein's planning methods and requirements of finish must be viewed in context: it is misleading to exaggerate his formality at the expense of all other interests. Another comment by the artist also had the effect of encouraging a pro-abstract reading: "Once I am involved with the painting I think of it as an abstraction. Half the time they are upsidedown anyway, when I work."[25] Again, this has been taken to mean that the subjects are not important to him, but that is not one's experience of the work. His iconography is not casual but persistent, and it supports cross-indexing as well as merely formal description, such as the recurrence of military subjects in his pastiches of the 1950s and in the Pop art of the '60s.

Consider these steps: first Lichtenstein selects the subject; then he makes a detailed sketch on the canvas, not so detailed that it cannot be changed but full enough to permit it to be worked on

71. *Self-Portrait II*, 1976
Oil and Magna on canvas, 70 x 54 in.
Paul and Diane Waldman, New York

72

72. *Razzmatazz*, 1978
Oil and Magna on canvas, 97 x 128 in.
Graham Gund

73. *Go for Baroque*, 1979
Oil and Magna on canvas, 107 x 167 in.
The Jeffrey H. Loria Collection, New York

upsidedown; and the image is presented in the finished painting, not lost in abstraction or process, but hard and clear. The fact that parts of the pictures were worked on when they were turned has been taken to mean that the subject was unimportant. It really means simply that the image is under control and highly stylized: turning it during work assures the artist of a final image locked in place. Owing to the prestige of abstract art, critics have associated almost all formal and pictorial procedures with it, while the act of representing objects or scenes has been attributed to dumb imitation. To see the work of Lichtenstein clearly, however, we need to remember that formality and representation are phases of a single artistic process, not antagonistic activities. The image that points like a sign and the image that coheres internally are identical: internal coherence enables a sign to function significatively.

Artistic originality was established as an aesthetic norm in the Renaissance. The artist's capacity to condense human experience in images not seen before was a prime test of humanistic art. However, the notion of perpetual invention as the proper role of artists is implicitly resisted by Lichtenstein's conspicuous quotations. In the sixteenth century personal originality was in fact compatible with the imitation of other artists' work, but not in the

74

1960s. Painting from quotation seemed to compromise the second user's originality. Given the diversity of Lichtenstein's sources and the character of his changes to them, we may be tempted to accept quotation itself as the form of originality. Is quotation a form of shielded invention in his hands, in which the twentieth-century desire to mint new images appears as the manipulation of existing signs? It may be among Lichtenstein's ironies to encourage this perception of his art, but his quotations are so demonstrative and numerous that we should be cautious of interpreting them in ways that reduce their rigorous and independent status. To equate an art premised on the use of allusion with art that is not so oriented is a failure of analysis. This is the trouble with criticism that over-emphasizes Lichtenstein's formality at the expense of his iconography.[26] Let us assume here the reality of the quotes and the possibility that they are a move against originality as a habit. The notion of originality has been democratized in art classes and commercialized by art dealers, since the initial brave assertion of

74. *Chef d'Oeuvre in Canoe*, 1955
Oil on canvas, 40 x 30 in.
Private collection

75. *Black Flowers*, 1961
Oil on canvas, 70 x 48 in.
Walter and Dawn Clark Netsch

76. *Cape Cod Still Life II*, 1973
Oil and Magna on canvas, 60 x 74 in.
Private collection

77. *Still Life with Silver Pitcher*, 1972
Oil and Magna on canvas, 51 x 60 in.
Mr. and Mrs. Bagley Wright

75

76

77

78

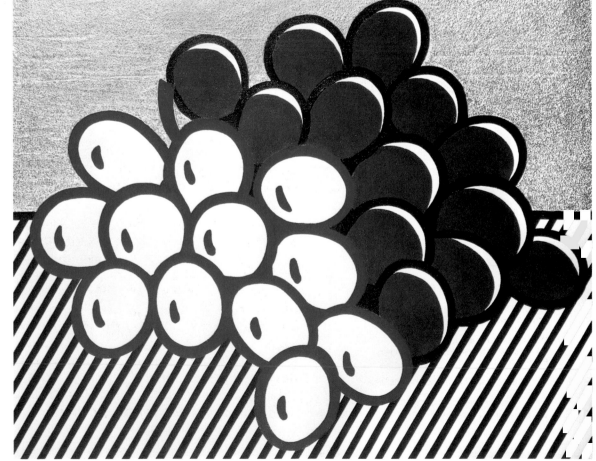

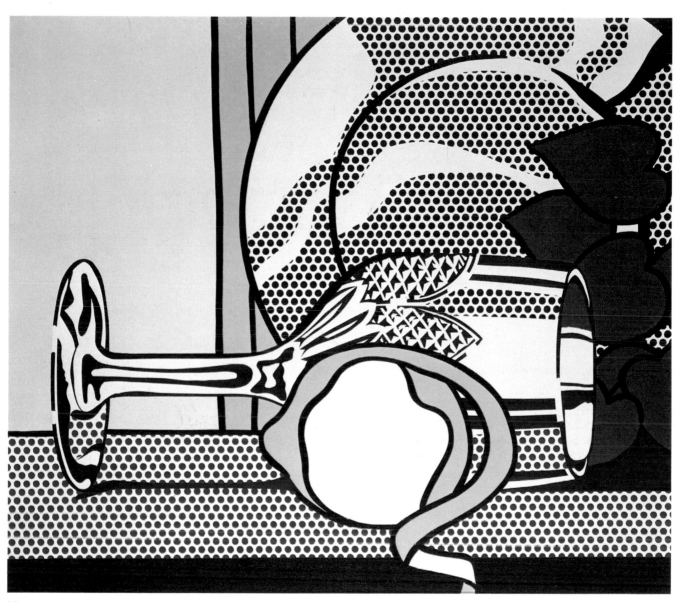

80

individuality by artists. If we consider some of the uses of citation in Lichtenstein's art, we will be in a better position to evaluate its expressivity.

The quotation of art in the past was often a matter of respect and learning. By putting a clothed eighteenth-century sitter in the pose of the Apollo Belvedere, an artist (the case is Joshua Reynolds's) evoked a classical type of male beauty recognizable as such by the instructed part of his public. The allusion declared the continuity of Greek and modern culture. The quotations by Lichtenstein, however, are not based on sharing a cultural source of acknowledged consultability and proven resonance. On the contrary, he puts quotation, whether of signs or styles, on another basis, often directing his spectators to discredited areas.

In the 1950s Lichtenstein drew on American narrative paintings of the nineteenth century, transposing by his style the treaty sign-

ings, military episodes, and historical encounters. This was derived from the immediately precedent painting of Picasso, the ambling and discursive Cubism of his postwar work in the south of France. In a shallow late Cubist space, figures in feathered headdresses and military uniforms infiltrate a style once closed to all exotics except the cast of the Commedia dell'arte. In *Chef d'Oeuvre in Canoe* (1955) Lichtenstein combines a verbal allusion to Picasso's illustrations for Balzac's *Chef d'oeuvre inconnu* with Americana, and his *Inside Fort Laramie* (1955) inserts indigenous figures into a nonchalant Cubist framework. Lichtenstein is evoking past models, not for their paradigmatic clarity, but as apparitions, surprises as sudden as twisters in the desert. We are talking about the artist before Pop art, and he was already concerned with the complexities of quotation.

Lichtenstein's paraphrases of nineteenth-century art seen through the painterly screen of a later style predate the general revival of interest in academic art of the period. His decision to use this area of discredited taste originated personally and not as a response to existing conditions. He later (1979) revived the imagery of American Indians that occurs in this work, but in terms of decoration, not genre. The sequence of Lichtenstein's periods, each finite but connectable with the others, is implicit here. This mix of continuity and revision is highly productive as a mode of thought geared to work.

From the American past, preserved in libraries and museums, Lichtenstein turned to mass-produced urban popular culture, the area that made him famous. Drawing from ads, catalogs, and of course comic strips, he assimilated popular graphics to easel painting, though at the time many assumed that he had simply opened art to the barbarians. "In Lichtenstein, this even goes so far as to produce canvases that are great simulated copies of tabloid engraving, reproduced down to the enlarged dots of the ink screen."[27] This was written by Max Kozloff, who concluded that "the art galleries are being invaded by the pin-headed and contemptible style of gum-chewers, bobby-soxers, and, worse, delinquents." He conceded his intemperance six years later, but is quoted here as typifying the Parent-Teacher Association reaction to the presence of low material in the temple of art. The PTA reflex in the 1950s covered both original and quoted comics.

At this point of tension between cultivated public taste and brute sources, Lichtenstein changed his subject. His references to reproductions of work by Cézanne, Picasso, and Mondrian (1962–64) led to an increasingly elaborate play with art and artists in his later work. Indeed, art became the fundamental term of his later iconography: in 1965 he began the series of Brushstrokes and in 1966 the Modern paintings, based on a concept of period style, not one-to-one citation. Later came the Mirrors and Entablatures, which were overlapped and succeeded by a series of still-life paintings (starting 1972), a trompe l'oeil phase (1973), and a proliferation of citations of European modern art. The concept of reference was expanded to include ambiguous sources as well as subtleties of translation.

Is Lichtenstein's work of the 1970s fundamentally unlike his

81. *Purist Painting with Bottles*, 1975
Oil and Magna on canvas, 80 x 40 in.
Wolverhampton Art Gallery and Museums, England

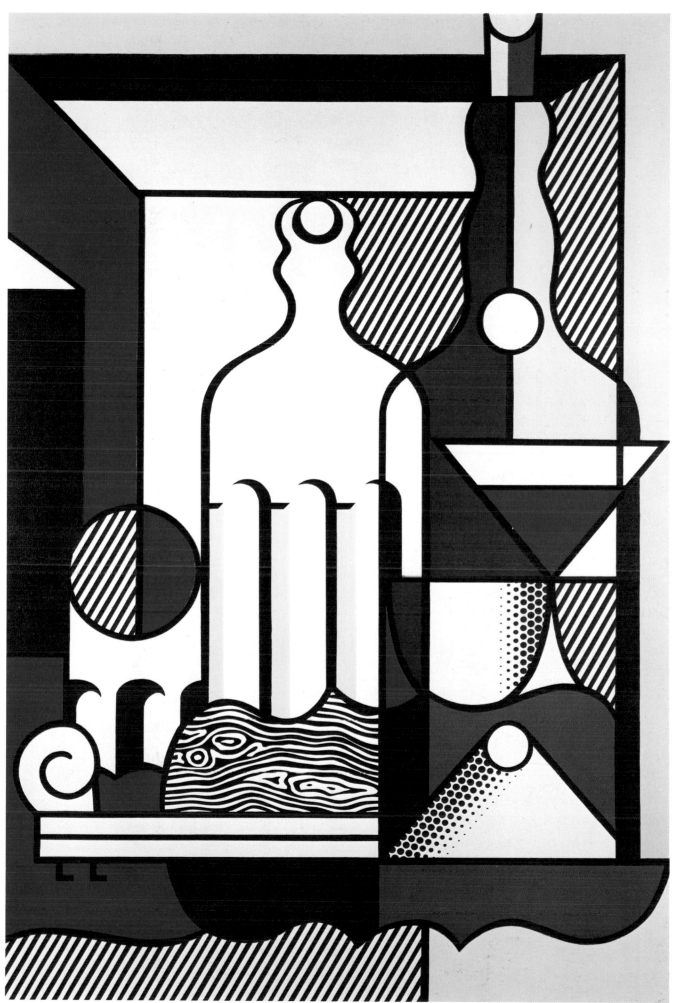

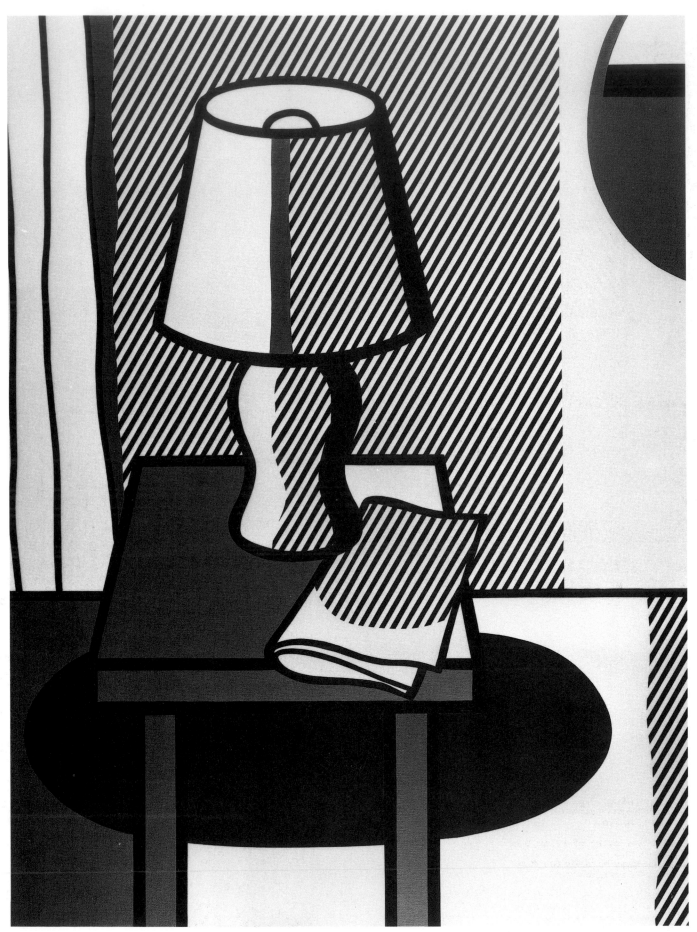

82

83

84

82. *Still Life with Table Lamp*, 1976
Oil and Magna on canvas, 74 x 54 in.
Private collection

83. *Purist Painting with Pitcher, Glass,
Column*, 1975
Oil and Magna on canvas, 60 x 40 in.
Mrs. Leo Castelli, New York

84. *Still Life with Folded Sheets*, 1976
Oil and Magna on canvas, 70 x 50 in.
Sydney and Frances Lewis Foundation,
Richmond, Virginia

85

work of the '60s? My sense, as I stated earlier, is that he is the
same artist in both decades: quoting an anonymous comic-book
artist is not so different from quoting Picasso in reproduction. In
both cases Lichtenstein is occupied with the act of quotation and
what it contributes to new works. His earlier pieces connect to the
visual communications of the 1960s, as Warhol's do; his later
works to the twentieth-century art movements of Cubism, Futur-
ism, Purism, Surrealism; but in both cases he attaches his work to
a capacious, preexisting fund of signs. The 1970s quotations from
within art should not mislead us into thinking that Lichtenstein's
interest is purely aesthetic. He is not setting up an art-for-art's-
sake loop of the kind that Ortega y Gasset, for one, thought was
central to modern art. On the contrary, Lichtenstein preserves
historical differences between source and variants. We are made
aware of the effect of a channel on what it transmits. The disparity
between that which is quoted and the form in which the quotation
is made builds distortion into the reference, any reference. The
clarity of Lichtenstein's composition is like a façade in front of
crumbling rooms.

The 1970s was rich in still life by many artists. Earlier in the
century artists and critics had tended to view the genre as a nearly
abstract form of painting: bottles and skulls, pitchers and books

85. *Still Life with Lamp*, 1976
Oil and Magna on canvas, 54 x 74 in.
Maximillian Schell and the
Richard Gray Gallery

were treated as geometric counters. Who could be interested in the meaning of dumb objects? The tendency of more recent still-life painting and criticism has been to restore the allusive dimension. This surely applies to Lichtenstein's still-life paintings, in which even the structure has a quotient of allusion: order is not an absolute standard, but observance of past style or a personal project.

An unnoticed effect of the prominence of abstract art was the dissolution of genres, the separate categories of figure composition, portraiture, landscape, and still life. They were swallowed up by general concepts of design in geometric abstract art, or of expression in gestural art. Although these modes were antithetical, the idea of abstract art as either construction or the ultimate painting experience proposes a similar homogenization of art. It was opposed in various ways by American artists in the 1960s, especially effectively by the Pop artists as they revived connections between painting and objects.

Lichtenstein's first phase of still-life painting (1961–62) was short but potent, and he did not return to the theme until 1971. But there is a sense in which all of Lichtenstein's work could be classified as still life: since he is quoting material, usually printed, he is dealing with things of daily use. However, when the field of the painting contains a vivid figurative image, as in, say, *Blam* or *Woman with Flowered Hat* (1963), it would be forced to insist on this formulation. Only when the depicted image is of an object or group of objects is it reasonable to call the work still life, as in *Golf Ball* and *Purist Painting with Bottles* (1975). Even so, there are differences to bear in mind: it is mandatory to distinguish between the monolithic single-image paintings of the 1960s and the formal correspondences among multiple objects in the '70s.

After the austere Mirrors, Lichtenstein did a group of still-life paintings that in their economy of objects and highly wrought detail are reminiscent of the polished high-life Dutch still lifes of the seventeenth century. They differ from the succeeding Purist paintings (1975–76) and the subsequent Office still lifes (1976). The implied milieu of the latter is rarely an office but, as Cowart has pointed out, the objects are derived "from newspaper ads and office-supply catalogues,"[28] presented soberly in a way that suggests utilitarian usage. Purism was a logical choice for Lichtenstein, because in the 1920s the movement programatically incorporated mass-produced articles into still life. In the paintings of Le Corbusier, Amédée Ozenfant, and Léger, there are such objects as thermos flasks, stacked plates, and fluted glasses. Lichtenstein imposes his own outlines on works that originally depended on silhouette and tonality, and devises his own cool color scheme, a range of greens, blues, and grays. Purism was a rationalization of Cubism, and Lichtenstein retains its tidy procedures. The fact that the objects are so clearly factory products is a continuation of the recurrent presence of the machine throughout Lichtenstein's art.

In Lichtenstein's Trompe l'Oeil paintings of 1973 an assumption of his earlier work is made explicit: the unlikeness of images to the objects they represent. He made the point that an object never coincides fully with the conventions used to depict it.[29] The separation of thing and image is a part of his working assumption

81

86

in the Trompe l'Oeil pictures. They exemplify the incompatability of reality (out there) and imagery (on the canvas). He takes the well-known formats of trompe l'oeil and demonstrates them in non-illusionistic terms. In *Things on the Wall* (1973) he takes a flat panel parallel to the canvas but gives us the bits and pieces nailed or pinned to it without simulating them. There is no deception: he uses a heavy sensuous line, reminiscent of the flexible thick line around Léger's *Bathers*, one of whom is present as a pinup. Thus the horseshoes, brushes, nail, and fly in the picture do not trick the eye. Illusionism is canceled in these apparent Trompe l'Oeil paintings: games of imitation are replaced by the split between style and subject matter.

European modern art was a problem for American artists in the 1940s and '50s. The Abstract Expressionists embraced European models, but combatively, with the intention of overcoming them. Barnett Newman's title, *Who's Afraid of Red, Yellow, and Blue* (which he repeated three times), is a typical way of referring to a European predecessor, in this case Mondrian. Lichtenstein, however, does not feel the need to wrestle; his later art is like a romance

86. *Trompe l'Oeil with Léger Head and Paintbrush*, 1973
Oil and Magna on canvas, 46 x 36 in.
Private collection

87. *Things on the Wall*, 1973
Oil and Magna on canvas, 60 x 74 in.
David Whitney

with modern European art. His view of Picasso, Matisse, and Léger is genial; he quotes their forms and makes them his own, pleased at their company. One of his Studio paintings is called *Artist's Studio, the "Dance"* (1974), and the dance is Matisse's. 89 Another, called *Artist's Studio, Look Mickey* (1973), refers to a 88 painting of Lichtenstein's own, one of the earliest in the comics style. Repeating *Look Mickey* in the context of an ideal studio makes a point: Lichtenstein is saying that public taste has validated his use of popular culture as a direct source of imagery. In the two Studio paintings, he is also comparing Matisse's work with his own—an audacity condoned by the market and by Lichtenstein's view of art as an array of provisional and deceptive signs in a continually unsettled state.

The so-called Surrealist paintings of 1977–79 include para-

89

88. *Artist's Studio, Look Mickey*, 1973
Oil and Magna on canvas, 96 x 128 in.
Walker Art Center, Minneapolis
Gift of Mr. and Mrs. Kenneth N. Dayton and
the T. B. Walker Foundation

89. *Artist's Studio, the "Dance,"* 1974
Oil and Magna on canvas, 96 x 128 in.
Mr. and Mrs. S. I. Newhouse, Jr., New York

90

phrases of fragmented Salvador Dali-esque heads, but the group might better be called the School of Paris paintings. And if the dates for that period were set at 1973–79, it would include the scenic still lifes of the Artist's Studios, the Purist and Cubist still lifes, and the Surrealist paintings. The last-named works are multi-figured and dense in incident. Fernand Léger, who seems to have slumbered behind some of Lichtenstein's earlier works, now wakes. His steady, winding, slow-moving contours and clear, bright patches ₃ of a limited number of colors are quoted openly. In *Stepping Out* (1978), the weird Surrealist girl is accompanied by a straight Léger boy—snapped together in the imaginary museum. Léger is present ₉₂ in other ways, too—for example, in *Still Life with Goldfish Bowl and Painting of a Golf Ball* (1972). The cylindrical fish bowl is a Matissean motif, as is the big-leaved plant, but both are given emphatically Légeresque contours. The plant expands in the background, overlapping a partial view of Lichtenstein's *Golf Ball*. There are three red goldfish and three lemons, the same yellow as all the yellow in Lichtenstein's paintings; the mouth of one fish

90. *Self-Portrait*, 1978
Oil and Magna on canvas, 70 x 54 in.
Private collection

91. *Girl with Tear III*, 1977
Oil and Magna on canvas, 50 x 42 in.
Private collection

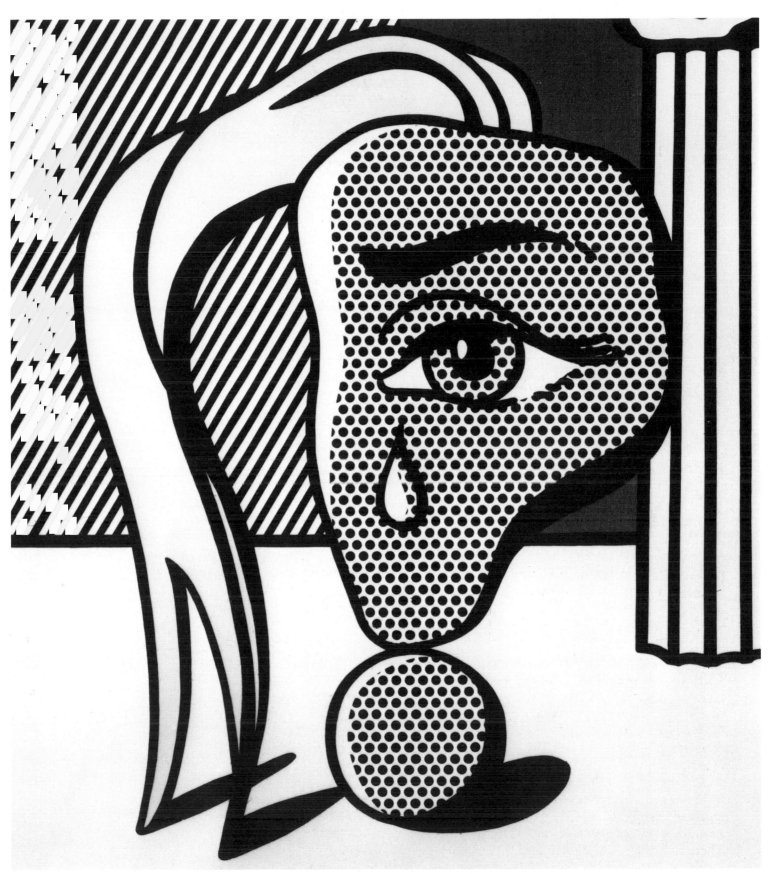

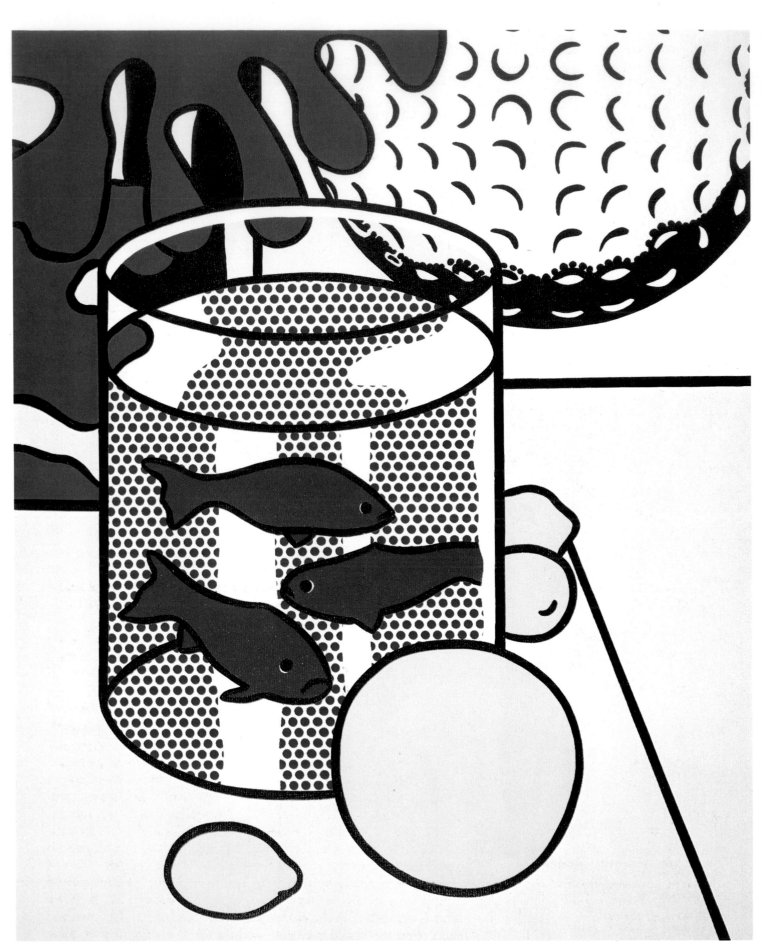

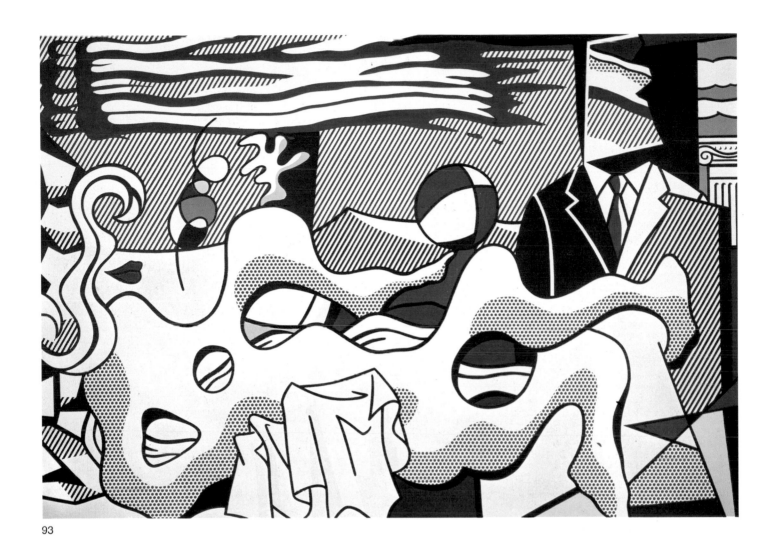

93

93

repeats an arc of the golf ball's indentations. This is essentially an Artist's Studio painting, with three artists cited in ironic interaction: Matisse, Léger, Lichtenstein.

The studio as a theme includes of necessity the mystique of the artist's workplace, as in Matisse's painted interiors that contain his own sculpture. Lichtenstein stays away from one possibility of the theme, its main appeal to Picasso, the intimacy of artist and model. On the other hand, he includes a sufficient number of quoted works to suggest a connection to another genre, the gallery picture. Laden with works of art, these paintings—like Jan Brueghel's *The Sense of Sight*; David Teniers's *Gallery of the Archduke Leopold William*; or Johann Zoffany's *Tribuna*, based on the Medici Collection—take culture itself as subject. The copious quotations in Lichtenstein's School of Paris period make a fantastic domain of overlapping images, out of frames and off pedestals. *Reclining Nude* (1977), for instance, represents a Henry Moore-ish sculptural body with a head made of Dali-esque clichés, full red lips, one eye, and a hank of blonde hair. In the upper background a big blue 1966-ish Lichtenstein Brushstroke doubles as sky (after all, his Brushstrokes did follow his cloud paintings). The tempered succession of formal incidents and the deliberate scatter of color

92. *Still Life with Goldfish Bowl and Painting of a Golf Ball*, 1972
Oil and Magna on canvas, 52 x 42 in.
Private collection

93. *Reclining Nude*, 1977
Oil and Magna on canvas, 84 x 120 in.
Private collection

94

95

segments, clustered rather than fused, has an amplitude reminiscent of the School of Paris between the wars. These works by Lichtenstein led to a group in which the patterning was tightened and brightened to assume an American Indian geometrization. When Lichtenstein lived in New York City in the 1960s, he had a big, glossy, three-dimensional reproduction of a totem pole in his loft, which looked like a tribal gas pump. The American Indian paintings, as they echo his Modern paintings, have a kind of anachronistic ethnicity, just the kind of cultural play to stimulate Lichtenstein's image-making faculty.

In the early 1970s Lichtenstein was dissatisfied, as we have seen, with the high art–low art dualism that he had smoothly mastered, and turned to high art–high art confrontation. Tensions between his art and its source continue in some phases of the later work, however: the Futurist paintings (1974) and the Expressionist paintings (1980). Unlike the other phases of Lichtenstein's quotations, they are marked by the kind of incongruity that showed up first in the Trompe l'Oeil period. In the Futurist works he subjects Carlo Carrà and Giacomo Balla paintings, based on the study of motion, to his own form sense, which leans toward closure and immobility (hence the rapport with Léger). The comic strips, of course, provided frantic images that were immobilized by Lichtenstein's handling, but that was part of the point—and the sources were anonymous. When Lichtenstein takes on Futurist paintings, however, he is absorbing the work of other artists, men like himself in many professional respects, and reevaluating their art. Futurist dynamism is wound down to a kind of schematic Cubism, a result with less irony than attended the freezing of the comics. The momentum that made his preceding use of unexpected quotation so convincing falters in this extension of the method.

Lichtenstein's later choice of German Expressionism as a source of allusion was startling and certainly exceeded the anticipation of admirers who identified him with his recent quotes from Léger and Matisse and thought of his design precedents as rooted in Paris. Lichtenstein's School of Paris period invited associations with Léger's *Le Grand Déjeuner* (1921), Braque's guéridon still lifes, and Picasso's *Mandolin and Guitar* (1924). By opting for northern European art, Lichtenstein seems to be reacting against the position he had created, a post-Abstract Expressionist romance with the School of Paris. That he drew on comics at a vigorous point in their zigzag history and predated the Art Deco revival in his Modern paintings show him as the possessor of a sensitized day-to-day cultural awareness. He turned to Expressionism at an opportune moment, also, but his relationship with it is strained. The demonstrative forms of Expressionism are picked up by an artist noted for his reticence and skills at distancing. First, there is the controlled discord of his Trompe l'Oeil paintings, then the semi-fit of Lichtenstein and his source in the case of Futurism, and finally the dislocation of his style and Expressionism. These works, with their echoes of Ernst Kirchner and Franz Marc, differ from the subsequent paintings in which unruly brushwork is separated from the function of quotation.

After the first phase of Expressionist allusion Lichtenstein slack-

94. *Pow Wow*, 1979
Oil and Magna on canvas, 97 x 120 in.
Mittelrheinisches Landesmuseum, Mainz
Ludwig Collection, Aachen

95. *Head with Braids*, 1979
Magna on canvas, 50 x 40 in.
Private collection

96

ened the historical references and incorporated a version of his own Brushstroke paintings. The scale is smaller and the marks, more scattered and numerous, have a descriptive function. The subjects, newly invented by the artist, are deliberately nondescript —modest still lifes, unremarkable landscapes. The paintings have an understated confidence in banality as a form of restraint: "free" expressionistic handling is presented laconically. Lichtenstein no longer systematizes the turbulent, as in the Brushstrokes, but confers a contradictory humbleness and elegance upon it. This period is both the latest manifestation of his concern with style as a subject and a reaffirmation of the iconographical resources of the quotidian, but in a sober form compared to the preceding paintings. This capacity of Lichtenstein's to surprise at the same time that he confirms his prior decisions is the sign of an artist in possession of a sustaining theme: recurrence and originality are supportive of one another.

Lichtenstein is uniquely characterized by his uses of quotation, but he is not alone in signifying by means of existing imagery. Quotation as self-record is often found in Matisse, a practice that intensified in his work in the 1940s. Picasso painted studio views in which the corporeal identity of the model is as real as the paint-

96. *Amerind Composition II*, 1979
Oil and Magna on canvas, 64 x 100 in.
Private collection

97. *Two Figures with Teepee*, 1979
Oil and Magna on canvas, 70 x 60 in.
Mr. and Mrs. Michael Klebanoff

ings on the wall. Especially important are Picasso's paraphrases of Lucas Cranach's *David and Bathsheba*, a series of lithographs, 1947. Another early pursuit of quotation is Francis Bacon's use of Velázquez's *Portrait of Pope Innocent X* as infrastructure for a series of his own paintings. R. B. Kitaj's painting alludes neither to first-person cues nor art historical sources alone, but to a matrix of references, many of them outside art history and beyond self-reference. These artists indicate the extent to which iconography became a flexible tool in the production of art. Image complexity was no longer restricted to art history (Erwin Panofsky and Edgar Wind entered the English language in the 1940s). It is not that I see Lichtenstein's interests, or those of the other artists, as dependent on prior iconography. The point is that as artists tired of Roger

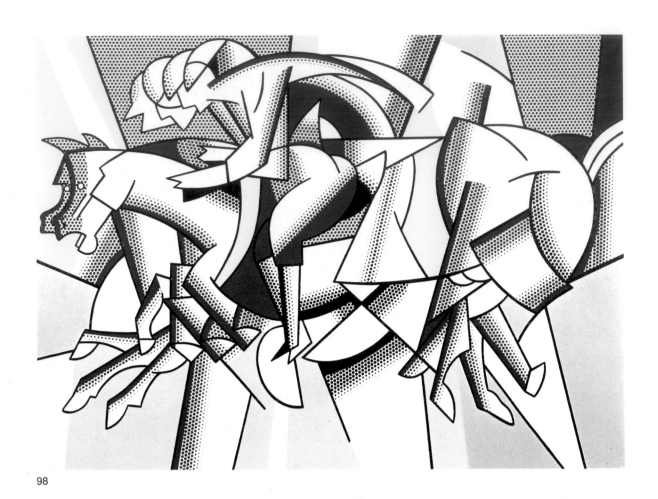

98

99

98. *Red Horseman*, 1974
Oil and Magna on canvas, 84 x 112 in.
Museum Moderner Kunst, Vienna
Ludwig Collection, Aachen

99. *Forest Scene*, 1980
Oil and Magna on canvas, 96 x 128 in.
Private collection

100. *Portrait of a Woman*, 1979
Oil and Magna on canvas, 70 x 54 in.
Private collection

101. *Expressionist Head*, 1980
Painted bronze, 55 x 44¾ x 18 in.
Edition of six

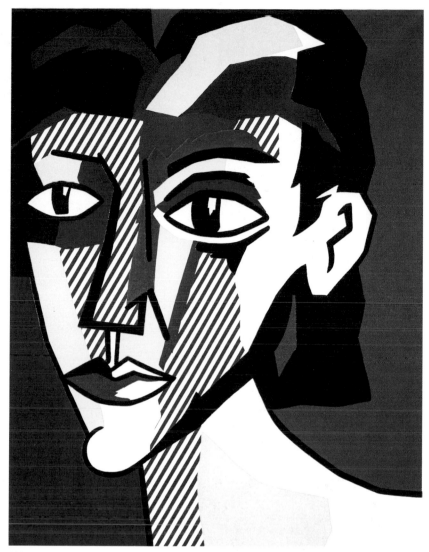

100

101

Fry, Robert Rey, and Albert Barnes (to take a British critic, a
French art historian, and an American aesthetician, all identified
with art as purely visual display), they encountered and instinctively
accepted the alternative of cultural iconography.

In Lichtenstein's work there is no pastoral sense of life, as in
Matisse or in Léger: there are only competing message systems and
fluctuating inventories of signs. Even the ample clouds, beams of
sunlight, and rippling seas of the Landscapes are not really pasto-
ral; they are the motifs of outdated but recycled taste. There is the
implication of evolutionary change and a discordant present in
Lichtenstein's parade of signs. This is not to say that he set out
with the intention of communicating such ideas, but that his work
functions in some such manner. He is studiously untheoretical
in his statements, but as one looks beyond the formal closure of
each painting, the sense of temporary and fallible communication
emerges as a persistent theme. Nothing occupies the present se-
curely; signs are provisional. Lichtenstein's interest in art history
does not mean that he is committed to a deterministic sequence of

102

103

102. *Sailboats*, 1981
Oil and Magna on canvas, 40 x 60 in.
Private collection

103. *Two Apples*, 1981
Magna on canvas, 24 x 24 in.
Private collection

104. *Woman III*, 1982
Oil and Magna on canvas, 80 x 56 in.
Private collection

105

events that converges on the present; it means that he views the past as a proliferating and multileveled set of possibilities.

In art history, iconography depends on the use of literary sources to explicate the meanings of the subject matter of visual art. This is not quite the sense assumed here. Iconography is identified with subject matter in the art of the 1960s and after, and to this extent it approximates the traditional sense of the term. However, to pursue specific sources for each image by every iconographically oriented artist would be an oppressive academic exercise. Here iconography is used to denote not point-by-point translation of a prior text, but susceptibility to the continuum of visual images that our culture, more than any other, has generated. There may well be traditional correspondences to documents, but openness to the

105. *Two Paintings with Dado*, 1983
Oil and Magna on canvas, 50 x 42 in.
Private collection

106. *Painting with Blue and Yellow Wood Grain*, 1983
Magna on canvas, 36 x 24 in.
Private collection

field of visual communications as a whole is also important. Recent painters who draw on preexisting photographic sources show that the sense of iconography as an open system, declared by Lichtenstein and the Pop artists, continues to be usable by artists who are in no sense imitators. The culture of reproductions has expanded our range of visualization immensely: on one hand, there are things not seen before; on the other, unanticipated comparisons between things. Lichtenstein does not view this as the equivalent of the Surrealist drama of the sewing machine and the umbrella on the operating table, even in his so-called Surrealist paintings. The normality of profusion is his iconographical base.

1. Diane Waldman, *Roy Lichtenstein*; Jack Cowart, *Roy Lichtenstein 1970–1980*. The exhibitions were held at the Solomon R. Guggenheim Museum, New York, 1969, and the Saint Louis Art Museum, 1981, respectively.

2. Cowart, *Lichtenstein*, p. 21.

3. Michael Brenson, "The Changing World of Roy Lichtenstein," p. 9.

4. John Coplans, ed. *Roy Lichtenstein*, 1972, p. 34. Coplans's book, with Cowart's later one, is the basic source of information on the artist.

5. See the author's *American Pop Art*, p. 15, for a reproduction of a professional comic-strip artist's reworking of Lichtenstein's *Emeralds*.

6. Paul Schwartz and Alain Robbe-Grillet, "Anti-Humanism in Art," in Coplans, *Lichtenstein*, 1972, pp. 164–67 (originally published 1968).

7. John Coplans, "Interview: Roy Lichtenstein," in Coplans, *Lichtenstein*, 1972, p. 100.

8. Lawrence Alloway, "Roy Lichtenstein's Period Style: From the 30s to the 60s and Back," in Coplans, *Lichtenstein*, 1972, p. 145.

9. Jasper Johns, in Leo Steinberg, *Jasper Johns* (New York: Wittenborn, 1963).

10. Bruce Glaser, "Oldenburg, Lichtenstein, Warhol: A Discussion," in Coplans, *Lichtenstein*, 1972, p. 57.

11. Coplans, "Interview: Roy Lichtenstein," p. 100.

12. John Coplans, "Talking with Roy Lichtenstein," in Coplans, *Lichtenstein*, 1972, p. 90.

13. Alan Solomon, "Conversation with Lichtenstein," in Coplans, *Lichtenstein*, 1972, p. 66.

14. Jeanne Siegel, "Thoughts on the 'Modern' Period," in Coplans, *Lichtenstein*, 1972, p. 94.

15. Solomon, "Conversation with Lichtenstein," p. 66.

16. Frederic Tuten, "Lichtenstein at Gemini," in Coplans, *Lichtenstein*, 1972, p. 98.

17. Coplans, "Talking with Roy Lichtenstein," p. 88.

18. Tuten, "Lichtenstein at Gemini," p. 95, in reference to John Coplans, "Claude Monet," in *Serial Imagery*, Pasadena: Pasadena Art Museum and Boston: New York Graphic Society, 1968, pp. 21–27.

19. Coplans, "Interview: Roy Lichtenstein," p. 102.

20. Elizabeth C. Baker, "The Glass of Fashion and the Mold of Form," in Coplans, *Lichtenstein*, 1972, p. 178.

21. Cowart, *Lichtenstein*, p. 31.

22. Roger Fry, "Art and Socialism," in *Vision and Design* (New York: Meridian Books, 1957; originally published, 1920), p. 68.

23. Cowart, *Lichtenstein*, p. 36.

24. Glaser, "Oldenburg, Lichtenstein, Warhol," p. 60.

25. Ibid., p. 61.

26. For example, Edward Fry, "Roy Lichtenstein's Recent Landscapes." *Art and Literature* 8 (Spring 1966): 111–19, and Richard Morphet, *Roy Lichtenstein*, London: Tate Gallery, 1968.

27. Max Kozloff, "Pop Culture, Metaphysical Disgust, and the New Vulgarians," in *Renderings: Critical Essays on a Century of Modern Art* (New York: Simon and Schuster, 1968; originally published, 1962), p. 219.

28. Cowart, *Lichtenstein*, p. 102.

29. Coplans, "Talking with Roy Lichtenstein," p. 87.

Artist's Statements

From a recorded telephone interview, February 1983.

LAWRENCE ALLOWAY You characteristically stress form in your statements, but what about iconography? I think that's been neglected.

ROY LICHTENSTEIN Oh, I always think that it's the formal part that gets neglected and that usually people talk about what the subject means. And when they do that, it sounds fairly obvious.

LA Why do you think the formal gets neglected?

RL I think it's the formal part that nobody understands. I don't think of form as a kind of architecture. The architecture is the result of the forming. It is the kinesthetic and visual sense of position and wholeness that puts the thing in the realm of art. Otherwise I think it is in the realm of an illustration of an idea. And I think that for most people the formal part is not what they see. One may be influenced by the sense of form and think it's really all right without understanding why. But the understanding of form is limited because I think people don't tend to see it unless they are artists. And I don't mean artists as a profession, because I think most artists don't see it either. I mean artists "for real."

LA Could it be we are talking about two different sets of people? I am thinking of all the critics who have written about your work and tended to emphasize form, whereas you could be talking about the people you meet at openings or on the beach.

RL That's possible, yes. And the reason the critics talk about form is because I do. I sort of insist that the problem is really form, because the work of art obviously has subject or content. I am pressing what I think is not obvious, particularly in relationship to the Abstract Expressionism that it came out of.

LA You say came "out of" Abstract Expressionism?

RL Well, I don't mean *it* came "out of" it. I think *I* may have. I was brought up on Abstract Expressionism, and its concern with forming and interaction is, I think, extremely important, even though I can't be seen to be interacting with the painting. It's very hard to tell where I have interacted with the developing work

because the tracks are not there. I think it's the nonexpressionist aspect of my training that allows my kind of compulsive thing to emerge.

LA You use an improvisatory procedure but cover your tracks.

RL Also, in many cases there is not any vast change between my source, my original drawing from it, and the end product, although there are real changes if you examine them.

LA Whenever I have seen your sources, the changes are pretty extensive.

RL Okay, then, that is evident, but sometimes it is not.

LA Although you say that the aspect of form is mysterious and I agree with you, I think that iconography has its mysteries too. For instance, critics have had great trouble trying to figure out your attitude to the comics you quoted.

RL Oh yes. It is because I seem to be swallowing the capitalist line whole. I think that's the problem. Well, it's fun to say you are, but I think of it as an ironic look at and use of what is usually called vulgar art. It's using those symbols to make something else. It's really the art we have around us; we're not living in the world of Impressionist painting.

LA To enter that world you have to go to a museum, whereas the vulgar art is always there, in every railroad station or newsstand.

RL Our architecture is not van der Rohe, it's really McDonald's, or little boxes.

LA By quoting such material and changing it as you do, what happens to it?

RL Well, the material has a bigness and brashness that is important, and it is industrial. It stands for the actual world we are in. For me, it has a "you're a bad boy copying comics" thing because our art teacher told us not to copy, and if you did copy, it certainly wouldn't be commercial art.

LA I didn't realize that.

RL I don't think it's major, but it's something.

LA It's like pretending you are doing a Ready-made when you really are not.

RL I am nominally copying, but I am really restating the copied thing in other terms. In doing that, the original acquires a totally different texture. It isn't thick or thin brushstrokes, it's dots and flat colors and unyielding lines. It seems to be antiart, but I don't think of it that way. I never thought it was Dada in that sense, though I thought it might *look* Dada.

LA It's a sort of simulated Dada. . . .

RL It's examining it, getting closer to it. It is like some of my later brushstroke apples. I am doing works now that incorporate prints of enlarged brushstrokes, fake brushstrokes, plus real brushstrokes.

LA That's what I mean about iconography. You go in for double-takes in your iconography no less than your form.

RL Yes, I'm thrilled about the idea that I am doing, particularly the apples with brushstrokes made out of false brushstrokes, because it says, "That's what *art* is." You know, I am always impressed by how artificial things look—like descriptions of office furniture in the newspapers. It is the most dry kind of drawing, as in the Mirrors. They really only look like Mirrors if someone tells

you they do. Only once you know that, they can be moved as far as possible from realism, but you want it to be taken for realism. It becomes as stylized as you can get away with, in an ordinary sense, not stylish.

LA What's the difference between Picasso's quotes of Velázquez and yours of Picasso?

RL I don't know that there's so much difference. I think there is a bigger difference when van Gogh does Rembrandt. It doesn't look like a Rembrandt, but it's extremely serious and has nothing to do with humor. Whereas Picasso doing Velázquez has something humorous about it. My work is closer to Picasso's in that there is something funny about it. The style is not like it. Well, the style of van Gogh is not like Rembrandt's, but you know van Gogh is deadly serious.

LA Picasso only quotes famous Velázquez paintings, whereas you tend to quote routine Picassos.

RL Well, there's something about brand names that I don't care for.

107. *Compositions III*, 1965
Magna on canvas, 56 x 48 in.
Irving Blum, New York

107

Notes on Technique

If this were a book about Jasper Johns the indirections of encaustic painting might need discussion, if about George Segal, life-casting and its effect on his iconography, but Lichtenstein's technique is pretty straightforward. It exists as a straight line leading to the images that we see as we look at his work. His way of painting does not depend on secrets, but on a systematically followed procedure. It is this sequence that must be the subject here, not pockets of ingenuity in the process of work. Lichtenstein's complexities are significative rather than procedural. In one phase of his work, the landscape and seascape collages of 1964–65, he departed from painting, using Rowlux (a highly reflective plastic) to pick up ambient light as sunset glow or sea ripple, and motorized kinetic pieces to produce light changes. But the kinetic landscapes and those with variable reflections are outnumbered by the painted ones in which a single state of screened dots simulates the play of light pictorially.

Until 1965 (the date is the artist's) Lichtenstein used commercially primed canvas as it came from the store. After that, he continued to use commercially primed canvas but topped it off with his own Magna Underpainting White to intensify and harden the surface. Since c. 1970 he has avoided ready-made priming altogether and builds the ground in his studio, using two thin coats of Liquitex Gesso (a water-based acrylic) and two of Underpainting White, soluble in turpentine, with layers of Magna Varnish between the coats of Magna. Thus, Lichtenstein has a dense and shining surface to paint on, a skin that rises to meet the solid facture of his paint: "I like it whiter now. Everything became sharper, I guess, as I went along and I just like that."[1]

Lichtenstein's solid zones of color are painted thinly, but in several coats of Magna, as a rule. The dots and parallel hatching are painted in oil, which gives the small elements a color-weight equivalent to the larger flat areas. Lichtenstein likes Magna because it is fully compatible with oil paint, which he used exclusively through 1962. In 1963 he alternated between oil and Magna, and in 1964 he achieved the mixture of the two that he has used since.

108–11. Lichtenstein at work on *Portrait*, July 1981
Photographs by Michael Abramson

The longer liquidity of the oil paint lends itself to use with the paper stencils by which he obtains his repetitive small forms. It dries slowly and is therefore more controllable: it does not clamp the surface immediately as an acrylic does. Errors and messes occurring in the process of work are expunged to preserve the clear image that Lichtenstein covets. If such areas get soiled in the clean up, they are taken out, down to and including the ground, and built up again.

Each painting begins with small pencil sketches, scaled to fit an opaque projector. They have an operational function, to bridge the distance between the quoted image and the form that Lichtenstein abstracts from it. The projected drawing is marked on the canvas in pencil, not so much drawn in as *located*, to use the artist's word. (The stretcher size and the proportion of the drawing are coordinated.) Then the embodiment of the image in paint begins, sometimes with additional clarifying drawings. Reflecting on his procedure, the artist said: "It sounds methodical, but it is open to change at any point."[2] The systematic aspect of his work is intimately bound to opportunities for revision and improvisation.

The emphatic precisions of Lichtenstein's paintings have often been taken as evidence of impersonality, depite contrary observations by the artist. He said in 1970: "I don't use tape because it masks out part of the painting. I like to let lines grow larger and smaller and to watch the whole painting while this is going on. I like the freedom of drawing a line in relationship to the whole painting. . . ."[3] In addition, lines drawn by painting along a tape tend, when the tape is pulled off, to have a weightless quality, as in the clean, disembodied edges of Kenneth Noland's straight-line paintings. The edge is free of the tremor of the hand and the sense of muscle behind it that are essential to accented directional drawing. The form-defining element in Lichtenstein is the thickening and thinning line, the variations of which are in contrast to the even color patches, the regular hatching, and the color points.

It is relevant at this point to discuss the function of an assistant, a role that is not always understood, owing to our cult of the autographic art of unique personalities. It is false to ascribe detachment or impersonality to art in which tasks are divisible between the artist and others. In an interview of 1970 John Coplans said to Lichtenstein:

I understand that for the Cathedral paintings you used an assistant quite extensively to cut the stencils.

Yes, and to paint the dots in, too.

All the tedious work is done by your assistant?

Yes.

As a consequence, your productivity has increased? Or your leisure?

Both.

You mean, without an assistant, you wouldn't have been able to tackle the Cathedral paintings—they'd have been too boring to do?

I don't think I thought of that. It wasn't too boring for Monet. I like to work. I even like repetitive jobs—but it would have taken me years, and I would rather carry out my other

109

110

ideas. . . . The fact that someone cuts the stencils exactly the way I would leaves no particular benefit for me to do it.[4]

This may be misleading if it suggests that an assistant was a new factor in the Cathedrals (1969), because the artist recalls that he employed an assistant by c. 1964. One of the advantages is that it gave him, he said, "freedom for other tasks."[5] A working process that permits somebody to do the dots "exactly the way I would" has an analogy to the relation of Sol LeWitt and his work. Whether LeWitt or an assistant executes the drawing on the wall, each is equally bound by the initial system that LeWitt has devised. However, different factors in Lichtenstein's case are his continual presence in the studio and the ongoing consultability of the assistant's work. There is a single surface that both the artist and his assistant paint on and it is fully visible; there are no delays in the return of information about the process-record. This is the importance of Lichtenstein's point that the work "is open to change at any point." His method separates him from neither conceptual control nor manual adjustment arising out of empirical decisions reached during work. These are the traditional benefits of easel painting: total control and continuous visibility of the developing work. It is why easel painting has been equated with artistic freedom since the early sixteenth century.

1. Diane Waldman, "Roy Lichtenstein Interviewed," in John Coplans, *Roy Lichtenstein*, 1972, p. 112.
2. The author in conversation with the artist, October 12, 1982.
3. John Coplans, "Interview: Roy Lichtenstein," in Coplans, *Lichtenstein*, 1972, p. 104.
4. Ibid., p. 103.
5. Conversation with the artist, October 12, 1982.

111

Chronology By Anna Brooke

1923 October 29—born in New York City, to Milton and Beatrice (Werner) Lichtenstein. His father is a realtor. Has one sister, Renée (born 1927).

1936–1940 Attends the Franklin School, Manhattan, New York, on 89th Street between Central Park West and Columbus Avenue.

1940 Attends summer art classes at the Art Students League, New York, where Reginald Marsh is his instructor.

1940–42 Attends School of Fine Arts, Ohio State University, Columbus, Ohio. Is influenced by Professor Hoyt L. Sherman's theory of perception.

1943 February—drafted by U.S. Army; stationed in Europe.

1946 January—discharged by U.S. Army. Returns to Ohio State University. June—graduates with B.F.A. Enters M.F.A. program. Is an instructor until 1951.

1949 Completes M.F.A. at Ohio State University. June 12—marries Isabel Wilson (divorced 1965). First group exhibition held at Chinese Gallery, New York.

1951 April—first solo exhibition in New York held at Carlebach Gallery. Summer—begins making woodcuts and etchings. Fall—moves to Cleveland.

1951–57 Works in Cleveland as graphic and engineering draftsman, window designer, sheet metal designer.

1952–55 Paints Far West and American history paintings.

1954 First son, David Hoyt Lichtenstein, born.

1956 Second son, Mitchell Wilson Lichtenstein, born.

1957–60 Is Assistant Professor of Art, State University of New York, Oswego, New York. Paints in an Abstract Expressionist style.

1960–64 Is Assistant Professor, Douglass College, Rutgers University, New Brunswick, New Jersey.

1961 Begins using cartoon images and techniques derived from commercial art (until 1965). Joins Leo Castelli Gallery.

1962 February—first solo exhibition at Leo Castelli Gallery. October—included in *New Realists*, the first important Pop art exhibition, held at Sidney Janis Gallery, New York.

1962–64 Paints reproductions of works by Cézanne, Mondrian, and Picasso.

1963 Moves to 26th Street in New York. Is one of ten painters and sculptors commissioned by architect Philip Johnson to make twenty-foot-square works for the outside wall of the circular theater, Circarama, New York State Pavilion, New York World's Fair. June—first solo exhibition in Europe held at Galerie Ileana Sonnabend, Paris.

1964–69 Paints the Architectural Monuments.

1965 Designs poster, *This Must Be the Place*, for National Cartoonists Society's convention in New York City. Begins working in ceramics. Makes the Explosion sculptures.

1965–66 Paints the Brushstrokes.

1966 October—Jackson China Company publishes edition of 800 signed place settings for Durable Disch Company. Moves to the Bowery and Spring Street. November—first solo museum exhibition held at Cleveland Museum of Art.

1966–67 Paints the Modern paintings.

1967 April—first museum retrospective exhibition held at Pasadena Art Museum, Pasadena, California. Paints large paintings for Expo '67, Montreal. November—first solo exhibition in Europe held at museums in Amsterdam, London, Bern, and Hannover.

1967–68 Makes the Modern sculptures.

1968 November 1—marries Dorothy Herzka.

1969 February—spends two weeks at Universal Film Studios in Los Angeles as artist-in-residence to make seascape film for the *Art and Technology* exhibition at Los Angeles County Museum of Art. Works in New York with Joel Freedman of Cinnamon Productions, experimenting with films. Paints the Rouen Cathedral paintings. June—*Rouen Cathedral* and *Haystack* prints published by Gemini. September—first New York museum retrospective exhibition organized and circulated by the Solomon R. Guggenheim Museum.

1970 Moves to Southampton, Long Island. Elected to the American Institute of Arts and Letters, New York. Designs four large murals for Düsseldorf University, College of Medicine. March–September—two of his seascape films shown at Expo '70, Osaka, Japan.

1970–72 Paints the Mirrors.

1971–72; 1974–76 Paints the Entablatures.

1973 Paints the Trompe l'Oeil paintings.

1973–79 Paints the School of Paris paintings.

1974 Paints the Futurist paintings.

1977 April 26—receives Skowhegan Medal for Painting. Begins making painted bronze sculpture.

1977–79 Paints the Surrealist paintings.

1979 Receives his first public sculpture commission, a grant from the National Endowment for the Arts for *Mermaid*, a ten-foot sculpture of steel and concrete for the Theater of the Performing Arts, Miami Beach, Florida. Paints the American Indian paintings.

1980 Paints the Expressionist paintings.

1981 Major retrospective of his work from the 1970s organized and circulated in America, Europe, and Japan by the Saint Louis Art Museum.

1982 Takes a loft in Manhattan, in addition to his Southampton studio.

113

112–13. Lichtenstein in his studio, July 1981
Photographs by Michael Abramson

114

Exhibitions

Solo Exhibitions

1951

Roy Lichtenstein, Carlebach Gallery, New York, April 30–May 12.
Roy Lichtenstein, John Heller Gallery, New York, December 16–January 12, 1952.

1953

Roy Lichtenstein, John Heller Gallery, January 26–February 6.

1954

Roy Lichtenstein, John Heller Gallery, March 8–27.

1957

Roy Lichtenstein, John Heller Gallery, January 8–February 26.

1959

Roy Lichtenstein, Condon Riley Gallery, New York, June 2–27.

1962

Roy Lichtenstein, Leo Castelli Gallery, New York, February 10–March 3.

1963

Roy Lichtenstein, Ferus Gallery, Los Angeles, April 1–27.
Lichtenstein, Galerie Ileana Sonnabend, Paris, June 5–30.
Roy Lichtenstein, Leo Castelli Gallery, September 28–October 24.

1964

Roy Lichtenstein Landscapes, Leo Castelli Gallery, October 24–November 19.
Roy Lichtenstein, Ferus Gallery, November 24–December.

1965

Lichtenstein, Galerie Ileana Sonnabend, June 1–30.
Roy Lichtenstein: Brushstrokes and Ceramics, Leo Castelli Gallery, November 20–December 11.

1966

Works by Roy Lichtenstein, Cleveland Museum of Art, Cleveland, November 4–December 1.

1967

Roy Lichtenstein, Pasadena Art Museum, April 18–May 28, and tour to Walker Art Center, Minneapolis.
Roy Lichtenstein: Painting and Sculpture, Leo Castelli Gallery, October 28–November 18.
Roy Lichtenstein: Schilderijen, émails, assemblages, tekeningen, Stedelijk Museum, Amsterdam, November 4–December 17, and tour to Tate Gallery, London; Kunsthalle, Bern; and Kestner-Gesellschaft, Hannover.
Roy Lichtenstein: Exhibition of Paintings and Sculpture, Contemporary Art Center, Cincinnati, December 7–January 15, 1968.

1968

Roy Lichtenstein, Irving Blum Gallery, Los Angeles.

1969

Roy Lichtenstein, Irving Blum Gallery, February 4–28.
Roy Lichtenstein: Rouen Cathedrals and Haystacks, New Gallery of Contemporary Art, Cleveland, September 4–24.
Roy Lichtenstein, Solomon R. Guggenheim Museum, New York, September 19–November 21, and tour to Museum of Contemporary Art, Chicago; Nelson Gallery-Atkins Museum, Kansas City; Seattle Art Museum; Columbus Gallery of Fine Arts, Columbus, Ohio.

1970

Roy Lichtenstein, Galerie Ileana Sonnabend, May.
Roy Lichtenstein: Graphics, Reliefs and Sculpture, 1969–1970, University of California, Irvine, October 27–December 6.

1971

Roy Lichtenstein: Mirror Paintings, Leo Castelli Gallery, March 13–April 9.
Roy Lichtenstein, Gemini Gallery, Los Angeles, May.
Roy Lichtenstein, John Berggruen Gallery, San Francisco, September 15–October 25.

Roy Lichtenstein, Irving Blum Gallery, October.
Roy Lichtenstein: Drawings, School of Visual Arts, New York, November 9–December 11.

1972

Roy Lichtenstein: Entablature Drawings, Leo Castelli Gallery, January 22–February 12.
Roy Lichtenstein, Contemporary Arts Museum, Houston, June 21–August 20.

1973

Roy Lichtenstein: Still Lifes, Leo Castelli Gallery, February 24–March 10.
Roy Lichtenstein, Galerie Beyeler, Basel, June–September.
Roy Lichtenstein: Trompe l'Oeil Paintings, Locksley Shea Gallery, Minneapolis, October 27–November 24.

1974

Roy Lichtenstein, Galerie Mikro, West Berlin, February.
Roy Lichtenstein: Recent Paintings, Mayor Gallery, London, April 2–May 18.
Roy Lichtenstein, Castelli Graphics, April 6–20.
Roy Lichtenstein: Six Still Lifes, Margo Leavin Gallery, Los Angeles, May 16–June 15.
Roy Lichtenstein: The Artist's Studio, Leo Castelli Gallery, November 2–30.

1975

Roy Lichtenstein: Dessins sans bande, Centre National d'Art Contemporain, Paris, January 10–February 17.
Roy Lichtenstein: Zeichnungen, Staatliche Museen Preussischer Kulturbesitz, Berlin, April 30–June 15.
Roy Lichtenstein: Sculpture 1967–68, Entablature Paintings, 1974–75, Ace Gallery, Los Angeles, May–June.
Roy Lichtenstein: Recent Paintings—Neue Werke, Galerie Beyeler, Kunstmesse, Basel, June 18–23.
The Graphic Art of Roy Lichtenstein, Fogg Art Museum, Cambridge, Massachusetts, September 13–October 26.
Roy Lichtenstein: Paintings and Graphics, Albert White Gallery, Toronto, October 18–November 13.
Roy Lichtenstein, Leo Castelli Gallery, November 1–22.

1976

Roy Lichtenstein: Collages, Visual Arts Museum, School of Visual Arts, New York, October 4–29.

1977

Roy Lichtenstein: The Entablature Series, Margo Leavin Gallery, January 12–February 5.
Roy Lichtenstein: Ceramic Sculpture, Art Galleries, California State University, Long Beach, February 22–March 20.
Roy Lichtenstein, Richard Gray Gallery, Chicago, April (?).
Roy Lichtenstein at Cal Arts: Drawings and Collages from the Artist's Collection, California Institute of the Arts, Valencia, April 19–May 22.
Roy Lichtenstein: Sculpture, Mayor Gallery, November 16–December 20.
Roy Lichtenstein: Sculpture, Leo Castelli Gallery, November 19–December 17.

Roy Lichtenstein: New Paintings, Blum Helman, New York, December.

1978

Roy Lichtenstein: Surrealist Paintings, Ace Gallery, Venice, California, January 29–February 28.
Roy Lichtenstein: Prints and Drawings, Leo Castelli Gallery, September 9–30.
Roy Lichtenstein: The Modern Work, 1965–1970, Institute of Contemporary Art, Boston, November 8–December 31.

1979

Roy Lichtenstein: Recent Work, Lowe Art Museum, University of Miami, Coral Gables, Florida, March 7–April 15.
Roy Lichtenstein: New Paintings, Leo Castelli Gallery, April 28–May 19.
Roy Lichtenstein: Mirrors and Entablatures, Fine Arts Center, State University of New York at Stony Brook, Stony Brook, Long Island, October 25–December 14.

1980

Roy Lichtenstein, Foster Gallery, University of Wisconsin, Eau Claire, January 22–February 14.
Roy Lichtenstein: Woodcuts and Etchings, Castelli Graphics, September 17–October 18.
Roy Lichtenstein: Recent Paintings, Mayor Gallery, October 16–November 15.
Roy Lichtenstein Exhibition, Portland Center for the Visual Arts, Portland, Oregon, March 4–April 27.

1981

Roy Lichtenstein 1970–1980, Saint Louis Art Museum, May 8–June 28, and tour to Seattle Art Museum; Whitney Museum of American Art; Fort Worth Art Museum; Museum Ludwig, Cologne; City of Florence; Musée des Arts Décoratifs, Paris; Fundacion Juan March, Madrid; Seibu Museum, Tokyo.
Roy Lichtenstein: Print Retrospective 1965–1980, Magnuson-Lee Gallery, Boston, June 13–July 31.
Roy Lichtenstein, Tower Gallery, Southampton, New York, August 8–21.
Roy Lichtenstein Graphic Work 1970–1981, Whitney Museum of American Art, Downtown Branch, October 4–November 25.
Roy Lichtenstein: New Works, Leo Castelli Gallery, October 17–November 7.
Roy Lichtenstein: Prints, Getler Pall, New York, October 20–November 14.
Roy Lichtenstein Tapestries, Mattingly Baker, Dallas, December 12–January 6, 1982.

1982

Roy Lichtenstein: Holzschnitte, Gimpel-Hanover and André Emmerich Gallerien, Zurich, February 27–April 10.
Roy Lichtenstein at Colorado State University, Colorado State University, Fort Collins, April 1–30.
Roy Lichtenstein: Paintings, Parrish Art Museum, Southampton, New York, August 8–September 19.
Roy Lichtenstein: Seven Apple Woodcuts, Castelli Graphics, November 20–December 18.

1983

Roy Lichtenstein, Daniel Templon, Paris, January 8–February 10.

Selected Group Exhibitions

1949

Chinese Gallery, New York, Summer.
Paintings by Roy Lichtenstein, Ceramics by Harry Schulke, Ceramics by Charles Lakofsky, Ten-Thirty Gallery, Cleveland, December 7–30.

1951

Fifth National Print Annual Exhibition, Brooklyn Museum, March 21–May 20.

1962

1961, Museum for Contemporary Arts, Dallas, April 3–May 13.
Drawings: Lee Bontecou, Jasper Johns, Roy Lichtenstein . . . , Leo Castelli Gallery, New York, May 26–June 30.
Art of Two Ages: The Hudson River School and Roy Lichtenstein, Mi Chou Gallery, New York, August 6–31.
New Paintings of the Common Object, Pasadena Art Museum, September 25–October 19.
The New Realists, Sidney Janis Gallery, New York, October 31–December 1.

1963

66th Annual American Exhibition, Art Institute of Chicago, January 11–February 10 (also included in 1972 exhibition).
Six Painters and the Object, Solomon R. Guggenheim Museum, New York, March 14–June 12.
Popular Art: Artistic Projections of Common American Symbols, Nelson Gallery-Atkins Museum, Kansas City, Missouri, April 28–May 26.
Pop Art USA, Oakland Art Museum, September 7–29.
The Popular Image, Institute of Contemporary Arts, London, October 24–November 23.
Mixed Media and Pop Art, Albright-Knox Art Gallery, Buffalo, November 19–December 15.
New Directions in American Painting, Munson-Williams-Proctor Institute, Utica, New York, December 1–January 5, 1964, and tour. Sponsored by the Poses Institute of Fine Art, Brandeis University.

1964

Amerikansk pop-konst, Moderna Museet, Stockholm, February 29–April 12, and tour.
'54–'64: Painting and Sculpture of a Decade, Tate Gallery, London, April–June.
XXe Salon de Mai, Musée d'Art Moderne de la Ville de Paris, May 16–June 7.

1965

New American Realism, Worcester Art Museum, Worcester, Massachusetts, February 18–April 4.
29th Biennial Exhibition of Contemporary American Painting, Corcoran Gallery of Art, Washington, D.C., February 26–April 18 (also included in 1971 and 1979 exhibitions).
American Landscapes, Festival di Spoleto, Spoleto, Italy, Summer. Organized by the International Council of the Museum of Modern Art.
1965 Annual Exhibition Contemporary American Painting, Whitney Museum of American Art, December 8–January 30, 1966 (also included in 1967, 1968, 1969, 1972, and 1973 exhibitions).
Word and Image, Solomon R. Guggenheim Museum, December.

1966

XXXIII Biennale, Venice, June 18–October 16.

1967

The 1960's: Painting and Sculpture from the Museum Collection, Museum of Modern Art, New York, June 28–September 24.
IX Bienal de São Paolo, Museu de Arte Moderna, São Paulo, September 22–January 8, 1968.
1967 Pittsburgh International Exhibition of Contemporary Painting and Sculpture, Museum of Art, Carnegie Institute, Pittsburgh, October 27–January 7, 1968.

1968

Pop Art and the American Tradition, Milwaukee Art Center, April 9–May 9.
Documenta 4, Museum Fridericianum, Kassel, West Germany, June 27–October 6.

1969

The Disappearance and Reappearance of the Image, Sala Dalles, Bucharest, January 17–February 2, and Smithsonian Institution Tour.
Contemporary American Sculpture: Selection 2, Whitney Museum of American Art, April 15–May 5.
Twentieth Century Art from the Nelson A. Rockefeller Collection, Museum of Modern Art, May 28–September 1.
Pop Art, Hayward Gallery, London, July 9–September 3. Organized by the Arts Council of Great Britain.
American Painting: The 1960's, Georgia Museum of Art, University of Georgia, Athens, September 22–November 3, and American Federation of Arts tour.
New York Painting and Sculpture: 1940–1970, Metropolitan Museum of Art, New York, October 18–February 1, 1970.
Painting in New York: 1944–1969, Pasadena Art Museum, November 24–January 11, 1970.

1970

Painting and Sculpture Today, Indianapolis Museum of Art, April 21–June 1 (also included in 1972 exhibition).

1971

Métamorphose de l'objet: Art et anti-art 1910–1970, Palais des Beaux-Arts, Brussels, April 22–June 6, and tour.
Technics and Creativity: Gemini GEL, Museum of Modern Art, May 5–June 6.
Art and Technology, Los Angeles County Museum of Art, May 11–August 29.

1972

Abstract Expressionism and Pop Art, Sidney Janis Gallery, February 9–March 4.

1973

American Art Third Quarter-Century, Seattle Art Museum, August 22–October 14.
New York Collection for Stockholm, Moderna Museet, October 27–December 2.

1974

Ars 74, Ateneumin Taidemuseo, Helsinki, February 15–March 31, and tour.
American Pop Art, Whitney Museum of American Art, April 6–June 16.
Picasso to Lichtenstein: Masterpieces of 20th Century Art from the Nordrhein Westfalen Collection in Düsseldorf, Tate Gallery, October 2–November 24.

1975

North, East, West, South and Middle: An Exhibition of Contemporary American Drawings, Moore College of Art Gallery, Philadelphia, February 28–April 4, and tour.
Richard Brown Baker Collects!: A Selection of Contemporary Art from the Richard Brown Baker Collection, Yale University Art Gallery, New Haven, April 24–June 22.
25 Stills, Whitney Museum of American Art, Downtown Branch, October 30–December 3.

1976

Twentieth-Century American Drawing: Three Avant-Garde Generations, Solomon R. Guggenheim Museum, January 23–March 21.
Zweihundert Jahre Amerikanische Malerei 1776–1976, Rheinischen Landes-Museum, Bonn, June 6–August 1, and tour. Organized by Baltimore Museum of Art.

1977

Amerikaner Kunst aus USA nach 1950, Kunstsammlung Nordrhein-Westfalen, Düsseldorf, October 28–January 8, 1978.

1978

Art about Art, Whitney Museum of American Art, July 19–September 24, and tour.
American Painting of the 1970's, Albright-Knox Art Gallery, December 8–January 14, 1979, and tour.

1979

Emergence and Progression: Six Contemporary American Artists, Milwaukee Art Center, October 11–December 2, and tour.

1980

The Fifties: Aspects of Painting in New York, Hirshhorn Museum and Sculpture Garden, Smithsonian Institution, Washington, D.C., May 22–September 21.

1981

Contemporary American Realism since 1960, Pennsylvania Academy of the Fine Arts, Philadelphia, September 18–December 13.
Art Materialized: Selections from the Fabric Workshop, New Gallery for Contemporary Art, Cleveland, December 11–January 16, 1982, and tour. Organized by Independent Curators, Inc.

1982

Surveying the Seventies: Selections from the Permanent Collection of the Whitney Museum of American Art, Whitney Museum of American Art, Fairfield County, Connecticut, February 12–March 31.
'60–'80: Attitudes, Concepts, Images, Stedelijk Museum, Amsterdam, April 9–July 11.
Focus on the Figure: Twenty Years, Whitney Museum of American Art, New York, April 15–June 13.

1983

Prints by Roy Lichtenstein and Andy Warhol, Albright-Knox Art Gallery, January 18–March 20.

114. *Two Apples*, 1982
Magna on canvas, 30 x 36 in.
Private collection

Public Collections

Aachen, West Germany, Neue Galerie-Sammlung Ludwig
Amsterdam, The Netherlands, Stedelijk Museum
Baltimore, Maryland, Baltimore Museum of Art
Buffalo, New York, Albright-Knox Art Gallery
Chicago, Illinois, Art Institute of Chicago
Cologne, West Germany, Wallraf-Richartz-Museum
Darmstadt, West Germany, Hessisches Landesmuseum
Dayton, Ohio, Dayton Art Institute
Denver, Colorado, Denver Art Museum
Des Moines, Iowa, Des Moines Art Center
Detroit, Michigan, Detroit Institute of Arts
Düsseldorf, West Germany, Kunstsammlung Nordrhein-Westfalen
Düsseldorf, West Germany, University, College of Medicine
Hartford, Connecticut, Wadsworth Atheneum
Humlebaek, Denmark, Louisiana Museum
Kansas City, Missouri, William Rockhill Nelson Gallery of Art and Mary Atkins Museum of Fine Arts
Kansas City, Missouri, Art Institute
London, England, Tate Gallery
London, England, Victoria and Albert Museum
Los Angeles, California, Los Angeles County Museum of Art
Mainz, West Germany, Mittelrheinisches Landesmuseum
Melbourne, Australia, National Gallery of Victoria
Miami, Florida, Theater of the Performing Arts
Milwaukee, Wisconsin, Milwaukee Art Center
Minneapolis, Minnesota, Minneapolis Institute of Arts
Minneapolis, Minnesota, Walker Art Center
Nagaoka, Japan, Nagaoka Museum
New Haven, Connecticut, Yale University Art Gallery
New York City, New York, Metropolitan Museum of Art

New York City, New York, Museum of Modern Art
New York City, New York, Solomon R. Guggenheim Museum
New York City, New York, Whitney Museum of American Art
Pasadena, California, Norton Simon Museum of Art
Philadelphia, Pennsylvania, Philadelphia Museum of Art
Providence, Rhode Island, Rhode Island School of Design, Museum of Art
Richmond, Virginia, Sydney and Frances Lewis Foundation
Ridgefield, Connecticut, Aldrich Museum of Contemporary Art
Rotterdam, The Netherlands, Museum Boymans-van Beuningen
Saint Louis, Missouri, Saint Louis Art Museum
San Francisco, California, San Francisco Museum of Modern Art
Stockholm, Sweden, Moderna Museet
Syracuse, New York, Everson Museum
Tehran, Iran, Tehran Museum of Contemporary Art
Tokyo, Japan, Seibu Art Museum
Vienna, Austria, Museum Moderner Kunst
Waltham, Massachusetts, Rose Art Museum, Brandeis University
Washington, D.C., Corcoran Gallery of Art
Washington, D.C., Hirshhorn Museum and Sculpture Garden, Smithsonian Institution
Washington, D.C., Library of Congress
Washington, D.C., National Gallery of Art
Washington, D.C., National Museum of American Art, Smithsonian Institution
Washington, D.C., National Portrait Gallery, Smithsonian Institution
Wellesley, Massachusetts, Wellesley College Museum
Wolverhampton, England, Wolverhampton Art Gallery and Museum

Selected Bibliography

Interviews and Statements

Andreae, Christopher. "Trying to Shock—Himself." *Christian Science Monitor*, September 18, 1969, sec. 2, p. 11. Studio interview before the Guggenheim exhibition.

Antoine, Jean. "Roy Lichtenstein." In Dypréau, Jean. "Métamorphoses: *L'École de New York*, un Film de Jean Antoine." *Quadrum* 18 (1965): 161–64. See p. 162. Interview.

Bushe, Ernst. "Interview mit Roy Lichtenstein." *Das Kunstwerk* 31 (February 1978): 14–25. Interview held August 31, 1977, in Southampton, New York.

Coplans, John. "An Interview with Roy Lichtenstein." *Artforum* 2 (October 1963): 31.

————. "Talking with Roy Lichtenstein." *Artforum* 5 (May 1967): 34–39. Reprinted as "Roy Lichtenstein: An Interview." In *Roy Lichtenstein*, Pasadena: Pasadena Art Museum, 1967. Also, excerpt reprinted in Barbara Rose, ed. *Readings in American Art 1900–1975*. New York: Praeger, 1975, pp. 153–54.

————. "Lichtenstein's Graphic Works: Roy Lichtenstein in Conversation." *Studio International* 180, Prints and Lithographs Supplement (December 1970): 263–65. Reprinted as "Interview: Roy Lichtenstein by John Coplans." In *Roy Lichtenstein: Graphics, Reliefs, and Sculpture, 1969–1970.*

————. "Interview mit Roy Lichtenstein." In *Roy Lichtenstein: Zeichnungen*, exhibition catalog. Berlin: Nationalgalerie, Staatliche Museen Preussischer Kulturbesitz, 1975, n.p.

Diamonstein, Barbaralee. "Caro, de Kooning, Indiana, Lichtenstein, Motherwell and Nevelson on Picasso's Influence." *Artnews* 73 (April 1974): 44–46. See pp. 45–46. Statement.

————. "Roy Lichtenstein and Leo Castelli." In *Inside New York's Art World*. New York: Rizzoli Editore, 1977, pp. 211–25. Interview.

Glaser, Bruce. "Oldenburg, Lichtenstein, Warhol: A Discussion." *Artforum* 4 (February 1966): 20. Edited transcript of WBAI, New York, broadcast, June 1964.

Glenn, Constance W. "Roy Lichtenstein: A Conversation." In *Roy Lichtenstein: Ceramic Sculpture*, exhibition catalog. Long Beach: California State University, 1977, pp. 17–23.

Holland, Mary. "Mr. Pop Comes to Town." *London Observer*, December 31, 1967, p. 7. Interview before Tate Gallery exhibition opening.

Independent Study Program. "Interview with Roy Lichtenstein." In *Roy Lichtenstein: Graphic Work 1970–1980*, exhibition brochure. New York: Whitney Museum of American Art, Downtown Branch, 1981, n.p.

Kuspit, Donald B.; Ratcliff, Carter; and Simon, John, interviews. Acconci, Vito, statement. "New York Today: Some Artists Comment." *Art in America* 65 (September 1977): 78–85. See pp. 82–83. Interview by Donald Kuspit.

Larson, Philip. "Roy Lichtenstein." In *Johns, Kelly, Lichtenstein . . .* , exhibition catalog. Minneapolis: Walker Art Center, 1974, pp. 16–18. Interview.

Lichtenstein, Roy. Talk at College Art Association annual meeting, Philadelphia, 1964. Reprinted in Ellen H. Johnson, ed. *American Artists on Art from 1940 to 1980*. New York: Harper and Row, 1982, pp. 102–4.

————. Statement in "Painting: Kidding Everybody." *Time* 89 (June 23, 1967): 72. Review of exhibition at Pasadena Museum of Art.

————. Statement in *Art Now: New York* 1, no. 1 (January 1969), n.p.

————. "Letters." *Artforum* 10 (June 1972): 6. Response to Lawrence Alloway. "On Style: An Examination of Roy Lichtenstein's Development, Despite a New Monograph on the Artist."

Pascal, David. "Interview with Roy Lichtenstein." *Giff Wiff* (Paris) 20 (May 1966): 6–15.

Roberts, Colette. "Interview de Roy Lichtenstein." *Aujourd'hui Art et Architecture* (Boulogne) 55–56 (December 1966–January 1967): 123–27. Includes English summary. Excerpts from an interview held March 1966 for her program "Meet the Artist."

Schaff, David. "A Conversation with Roy Lichtenstein." *Art International* 23 (January–February 1980): 28–39.

Shapiro, David. "Roy Lichtenstein: Grande Unificazione." In Attilio Codognato. *Pop Art: Evoluzione di una generazione*. Milan: Electa Editrice, 1980, pp. 63–68. Interview.

Siegel, Jeanne. "Roy Lichtenstein." Transcript of radio interview on WBAI, New York, December 13, 1967. Reprinted as "Thoughts on the 'Modern' Period" in John Coplans, ed. *Roy Lichtenstein*. Praeger, 1972, pp. 91–95.

Smith, Phillip. "Roy Lichtenstein: Interview." *Arts Magazine* 52 (November 1977): 26.

Solomon, Alan. "Conversation with Lichtenstein." *Fantazaria* 1 (July–August 1966): 36–43. Issue devoted to Lichtenstein.

Sorin, Raphael. "Le Classicisme du hot dog." *La Quinzaine Littéraire* 42 (January 1968): 16–17. Interview.

Swenson, G. R. "'What Is Pop Art?': Answers from Eight Painters, Part 1: Jim Dine, Robert Indiana, Roy Lichtenstein, Andy Warhol." *Artnews* 62 (November 1963): 24–27, 60–64. Reprinted in John Russell and Suzi Gablik. *Pop Art Redefined*. New York: Praeger, 1969, pp. 92–94; in Barbara Rose, ed. *Readings in American Art 1900–1975*. New York: Praeger, 1975, pp. 152–53; and in Ellen H. Johnson, ed. *American Artists on Art from 1940 to 1980*. New York: Harper and Row, 1982, pp. 79–104.

Tuchman, Phyllis. "Pop!: Interviews with George Segal, Andy Warhol, Roy Lichtenstein, James Rosenquist, and Robert Indiana." *Artnews* 73 (May 1974): 24–29.

Tuten, Frederic. *Lichtenstein at Gemini*, catalog. Los Angeles: Gemini G.E.L., 1969. Interview.

Waldman, Diane. "Roy Lichtenstein Interviewed." In *Roy Lichtenstein*. Harry N. Abrams, 1972. Reprinted in *Art Press* 15 (January 1974–February 1975): 6–7.

Monographs and Solo-Exhibition Catalogs

Abadie, Daniel. Preface to *Roy Lichtenstein: Dessins sans bande*, exhibition catalog. Paris: Centre National d'Art Contemporain, 1975.

Alloway, Lawrence. *Roy Lichtenstein*, exhibition catalog. Houston: Contemporary Arts Museum, 1972.

———. *Mirrors and Entablatures*. Stony Brook: State University of New York at Stony Brook, 1979.

Coplans, John. *Roy Lichtenstein*, exhibition catalog. Pasadena: Pasadena Art Museum, 1967. Includes interview.

———. Preface to *Roy Lichtenstein: Graphics, Reliefs, and Sculpture, 1969–1970*, exhibition catalog. Irvine: University of California, 1970. Includes interview.

———, ed. *Roy Lichtenstein*. New York: Praeger, 1972. Includes reprints of interviews by: John Coplans, "Interview: Roy Lichtenstein," "An Interview with Roy Lichtenstein," "Roy Lichtenstein Interviewed" ("Talking with Roy Lichtenstein"); Bruce Glaser, "Oldenburg, Lichtenstein, Warhol: A Discussion"; Jeanne Siegel, "Thoughts on the 'Modern' Period"; Alan Solomon, "Conversation with Roy Lichtenstein"; G. R. Swenson, "What Is Pop Art?"; Frederic Tuten, "Lichtenstein at Gemini"; and Diane Waldman, "Roy Lichtenstein Interviewed." Includes reprints of: Lawrence Alloway, "Roy Lichtenstein's Period Style"; Elizabeth C. Baker, "The Glass of Fashion and the Mold of Form"; Gene Baro, "Roy Lichtenstein: Technique as Style"; Nicolas Calas, "Roy Lichtenstein: Insight through Irony"; Otto Hahn, "Roy Lichtenstein"; Richard Morphet, "Roy Lichtenstein"; Alain Robbe-Grillet, "Anti-Humanism in Art"; and Robert Rosenblum, "Roy Lichtenstein and the Realist Revolt."

———. *Roy Lichtenstein: Trompe l'Oeil Paintings*, exhibition catalog. Minneapolis: Locksley Shea Gallery, 1973.

———. *Roy Lichtenstein*. London: Allen Lane, 1974.

Cowart, Jack. *Roy Lichtenstein 1970–1980*, exhibition catalog. New York: Hudson Hills Press and Saint Louis: Saint Louis Art Museum, 1981.

Glenn, Constance W. *Roy Lichtenstein: Ceramic Sculpture*, exhibition catalog. Long Beach: California State University, 1977. Includes inteview.

Jouffroy, Alain. Preface to *Lichtenstein*, exhibition catalog. Paris: Ileana Sonnabend, 1963. Includes Ellen H. Johnson, "Notes sur Roy Lichtenstein" and Robert Rosenblum, "Roy Lichtenstein and the Realist Revolt."

Kaprow, Allan. *Roy Lichtenstein at Cal Arts: Drawings and Collages from the Artist's Collection*, exhibition catalog. Valencia: California Institute of the Arts, 1977.

Kerber, Bernhard. *Roy Lichtenstein: Ertrinkendes Mädchen*. Stuttgart: Philipp Reclam, 1970. Includes reprints of interviews by John Coplans, "Talking with Roy Lichtenstein"; David Pascal, "Interview with Roy Lichtenstein"; Alan Solomon, "Conversation with Roy Lichtenstein"; Raphael Sorin, "Le Classicisme du hot dog"; G. R. Swenson, "What Is Pop Art?"

Kuspit, Donald B. *Roy Lichtenstein: Recent Work*, exhibition catalog. Coral Gables, Fla.: Lowe Art Museum, University of Miami, 1979. Excerpts from "Lichtenstein and the Collective Unconscious of Style."

Lichtenstein, exhibition catalog. Paris: Ileana Sonnabend, 1965. Includes reprint of interview by G. R. Swenson, "What Is Pop Art?"

Morphet, Richard. *Roy Lichtenstein*, exhibition catalog. London: Tate Gallery, 1968. Includes reprints of interviews by John Coplans, "Roy Lichtenstein: An Interview," and G. R. Swenson, "What Is Pop Art?"

———. Preface to *Roy Lichtenstein*, exhibition catalog. Basel: Galerie Beyeler, 1973. Includes excerpts from the Tate Gallery catalog and statements by Roy Lichtenstein.

———. Preface to *Roy Lichtenstein: Sculpture*, exhibition catalog. New York: Leo Castelli and London: Mayor Gallery, 1977.

Rose, Barbara. Preface to *Roy Lichtenstein: Entablature Series*, catalog. Bedford Village, N.Y.; Tyler Graphics, 1976.

Schmied, Wieland. *Roy Lichtenstein: Zeichnungen*, exhibition catalog. Berlin: Nationalgalerie, Staatliche Museen Preussischer Kulturbesitz, 1975. Includes interview.

Sussman, Elisabeth. Preface to *Roy Lichtenstein: The Modern Work, 1965–1970*, exhibition catalog. Boston: Institute of Contemporary Art, 1978.

Tuten, Frederic. *Lichtenstein at Gemini*, catalog. Los Angeles: Gemini GEL, 1969. Includes interview.

Waldman, Diane. *Roy Lichtenstein*, exhibition catalog. New York: Solomon R. Guggenheim Museum, 1969.

———. *Roy Lichtenstein*. New York: Harry N. Abrams, 1972, and Milan: Gabriele Mazzotta, 1971. Includes interview.

———. *Roy Lichtenstein: Drawings and Prints*. New York: Chelsea House, 1971.

Whitford, Frank. Preface to *Roy Lichtenstein: Recent Paintings*, exhibition catalog. London: Mayor Gallery, 1974.

Wilde, E. de. Foreword to *Roy Lichtenstein: Schilderijen, émails, assemblages, tekeningen*, exhibition catalog. Amsterdam: Stedelijk Museum, 1967. Includes essay by W. A. L. Beeren and reprint of John Coplans, "Roy Lichtenstein: An Interview."

Williams, Ron G. *Roy Lichtenstein at Colorado State University*, exhibition catalog. Fort Collins: Colorado State University, 1982.

Zerner, Henri. *The Graphic Art of Roy Lichtenstein*, exhibition catalog. Cambridge: Fogg Art Museum, 1975.

Periodicals, Books, and Group-Exhibition Catalogs

Alloway, Lawrence. "Notes on Five New York Painters." *Gallery Notes, Albright-Knox Art Gallery* 26 (Autumn 1963): 13–20. Discussion of *Head, Red and Yellow*, 1962.

———. "Roy Lichtenstein's Period Style." *Arts Magazine* 42 (September–October 1967): 24–29.

———. "Roy Lichtenstein." *Studio International* 175 (January 1968): 25–31. Adapted from "Roy Lichtenstein's Period Style" and other material.

———. "On Style: An Examination of Roy Lichtenstein's Development, Despite a New Monograph on the Artist." *Artforum* 10 (March 1972): 53–59. Discussion of Diane Waldman's *Roy Lichtenstein*, Harry N. Abrams, 1972.

———. "Roy Lichtenstein." In *American Pop Art*. New York: Macmillan, 1974, pp. 75–86. An expanded version of the *Artforum* article.

Baker, Elizabeth C. "The Glass of Fashion and the Mold of Form: Roy Lichtenstein's New Paintings. . . ." *Artnews* 70 (April 1971): 40–41, 65–66. Review of the Mirrors at Leo Castelli Gallery.

Bannard, Darby. "Present-Day and Ready-Made Styles." *Artforum* 5 (December 1966): 30–35.

Baro, Gene. "Roy Lichtenstein: Technique as Style." *Art International* 12 (November 1968): 35–38.

Boatto, Alberto. "The Comic Strip under the Microscope." *Fantazaria* 1 (July–August 1966): 52–61. Issue devoted to Lichtenstein.

Boime, Albert. "Roy Lichtenstein and the Comic Strip." *Art Journal* 28 (Winter 1968–69): 155–59.

Brenson, Michael. "The Changing World of Roy Lichtenstein." *New York Times*, August 10, 1982, sec. C, p. 9.

Calas, Nicolas. "Roy Lichtenstein: Insight through Irony." *Arts Magazine* 44 (September–October 1969): 29–33. Reprinted in *Icons and Images of the Sixties*. New York: E. P. Dutton, 1971, pp. 102–10.

Calvesi, Maurizio. "Lichtenstein: A Global Painter." *Fantazaria* 1 (July–August 1966): 44–51. Issue devoted to Lichtenstein.

———. "Oldenburg, Dine, Warhol, Segal, Lichtenstein." In *Le Due Avanguardie*, vol. 2. Bari: Editori Laterza, 1971, pp. 333–52.

Canaday, John. "Art: The Lichtenstein Retrospective." *New York Times*, September 20, 1969, p. 25. Review of exhibition at the Guggenheim Museum.

———. "Roy Lichtenstein and His Great Big Yacht." *New York Times*, September 21, 1969, sec. D, p. 29. Review of exhibition at the Guggenheim Museum.

Chafetz, Sidney. "Four Early Lichtenstein Prints." *Artists Proof* 10 (1970): 48–52.

Cowart, Jack. "Roy Lichtenstein 1970–1980: Beyond Pop." *American Artist* 45 (July 1981): 42–49.

Danoff, I. Michael. "Paintings That Make Your Retinas Dance." *Artnews* 80 (November 1981): 122–25. Review of exhibition at the Whitney Museum.

115. *Flowers*, 1982
Magna on canvas, 50 x 36 in.
Private collection

Deitcher, David. "Lichtenstein's Expressionist Takes." *Art in America* 71 (January 1983): 84–89.

Fry, Edward. "Roy Lichtenstein's Recent Landscapes." *Art and Literature* 8 (Spring 1966): 111–19.

———. "Inside the Trojan Horse: Lichtenstein at the Guggenheim. . . ." *Artnews* 68 (October 1969): 36–39, 60.

Geldzahler, Henry. "Frankenthaler, Kelly, Lichtenstein, Olitski." *Artforum* (June 1966): 32–38. A preview of the American selection for the 1966 Venice Biennale catalog; revised version of essay for the catalog.

Glueck, Grace. "Blam!! To the Top of the Pop." *New York Times*, September 21, 1969, sec. D, p. 31.

Gruen, John. "Roy Lichtenstein: From Outrageous Parody to Iconographic Elegance." *Artnews* 75 (March 1976): 39–42.

Hahn, Otto. "Roy Lichtenstein." *Art International* 10 (Summer 1966): 64, 66–69.

Hamilton, Richard. "Roy Lichtenstein." *Studio International* 175 (January 1968): 20–24. Review of exhibition at the Tate Gallery of Art. Reprinted in John Russell and Suzi Gablik. *Pop Art Redefined.* Praeger, 1969, pp. 88–91.

Johnson, Ellen H. "The Image Duplicators—Lichtenstein, Rauschenberg, and Warhol." *Canadian Art* 23 (January 1966): 12–19. Reprinted in *Modern Art and the Object.* Harper and Row, 1976, pp. 176–91.

———. "Lichtenstein: The Printed Image at Venice." *Art and Artists* 1 (June 1966): 12–15. Venice Biennale number. Reprinted in *Fantazaria* 1 (July–August 1966): 106–9. Issue devoted to Lichtenstein.

———. "The Lichtenstein Paradox." *Art and Artists* 2 (January 1968): 12–15. Reprinted as "Style as Object" in *Modern Art and the Object*, pp. 191–95.

Kozloff, Max. "Dissimulated Pop." *The Nation*, November 30, 1964, pp. 417–19. Reprinted in *Fantazaria* 1 (July–August 1966): 102–5. Issue devoted to Lichtenstein. Review of exhibition at Leo Castelli Gallery and others.

———. "Lichtenstein at the Guggenheim." *Artforum* 8 (November 1969): 41–45.

Kramer, Hilton. "The New Sculpture: Aspirations and Blind Alleys." *New York Times*, November 12, 1967, sec. 2, p. 37. Review of exhibition at Leo Castelli Gallery.

Kuspit, Donald B. "Lichtenstein and the Collective Unconscious of Style." *Art in America* 67 (May–June 1979): 100–105. Discussion of Lichtenstein's treatment of Surrealism.

Loran, Erle. "Cézanne and Lichtenstein: Problems of 'Transformation.'" *Artforum* 2 (September 1963): 34–35.

———. "Pop Artists or Copy Cats?" *Artnews* 62 (September 1963): 48–49, 61. Discussion of the *Portrait of Mme. Cézanne* and the *Six Painters and the Object* exhibition organized by the Guggenheim Museum.

Menna, Filiberto. "The Organized Perception of Lichtenstein." *Fantazaria* 1 (July–August 1966): 62–65. Issue devoted to Lichtenstein.

Meyer, Jean-Claude. "Les Illusions optiques de Roy Lichtenstein." *XXe Siècle* n.s. 41 (December 1973): 88–93.

Porter, Fairfield. "Roy Lichtenstein." *Artnews* 50 (January 1952): 76. Review of exhibition at Heller Gallery.

———. "Roy Lichtenstein." *Artnews* 51 (February 1953): 74. Review of exhibition at Heller Gallery.

———. "Lichtenstein's Adult Primer." *Artnews* 53 (March 1954): 18, 63. Review of exhibition at Heller Gallery.

Robbe-Grillet, Alain. "Anti-Humanism in Art: Alain Robbe-Grillet in an Interview with Paul Schwartz." *Studio International* 175, supplement, *Studiographic* 1 (April 1968): 168–69. Reprinted in John Coplans, ed. *Roy Lichtenstein.* Praeger, 1972, pp. 164–66.

Rose, Barbara, and Sandler, Irving. "Sensibility of the Sixties." *Art in America* 55 (January–February 1967): 44–57. Reprinted in Barbara Rose, ed. *Readings in American Art 1900–1975.* New York: Praeger, 1975, pp. 186–93.

Rosenblum, Robert. "Roy F. Lichtenstein." *Art Digest* 28 (February 15, 1954): 22. Review of exhibition at Heller Gallery.

———. "Roy Lichtenstein and the Realist Revolt." *Metro* 8 (April 1963): 38–45.

———. "Lichtenstein at the XXXIII Venice Biennale." *Fantazaria* 1 (July–August 1966): 110–11. Issue devoted to Lichtenstein.

Rublowsky, John. *Pop Art.* New York: Basic Books, 1965, pp. 42–59. Chapter on Lichtenstein and early quotes.

Russell, John. "Pop Reappraised." *Art in America* 57 (July–August 1969): 78–79. John Russell and Suzi Gablik organized the *Pop Art* exhibition at the Hayward Gallery for the Arts Council of Great Britain.

———. "Art Moderne: Roy Lichtenstein, Pop No. 1." *Connaissance des arts* (October 1969): 19–23. Review of exhibition at the Guggenheim Museum.

———. "Seeing More Than Just Fun in Lichtenstein." *New York Times*, September 5, 1982, sec. 2, p. 17.

Schjeldahl, Peter. "The Artist for Whom Style Is All." *New York Times*, March 21, 1971, sec. B, p. 21. Review of exhibition at Leo Castelli Gallery.

Schlanger, Jeff. "Ceramics and Pop—Roy Lichtenstein." *Craft Horizons* 26 (January–February 1966): 42–43. Review of exhibition at Leo Castelli Gallery.

Sieberling, Dorothy. "Is He the Worst Artist in the U.S.?" *Life* 56 (January 31, 1964): 78–83.

Solomon, Alan. "The New American Art." *Art International* 8 (March 20, 1964): 54–55.

Swenson, G. R. "The New American 'Sign Painters.'" *Artnews* 61 (September 1962): 44–47, 60–62.

Tillim, Sidney. "Roy Lichtenstein and the Hudson River School." *Arts Magazine* 37 (October 1962): 55–56. Review of exhibition at Mi Chou Gallery.

———. "Lichtenstein's Sculptures." *Artforum* 5 (January 1968): 22–24.

Tuchman, Maurice. "Roy Lichtenstein." In *A Report on the Art and Technology Program of the Los Angeles County Museum of Art, 1967–1971*. Los Angeles: Los Angeles County Museum of Art, 1971, pp. 194–99.

Waldman, Diane. "Remarkable Commonplace." *Artnews* 66 (October 1967): 28–31, 65–67.

Young, Joseph E. "Lichtenstein Printmaker." *Art and Artists* 4 (March 1970): 50–53. Includes statements from interviews with Roy Lichtenstein and Kenneth Tyler.

116

116. *Ohhh . . . Alright . . .* , 1964
Magna on canvas, 36 x 36 in.
Courtesy Andrew Crispo Gallery, New York

Index

Photography Credits

All photographic material was obtained directly from the collection indicated in the caption, except for the following: Courtesy of the author: plates 22, 38; Blum Helman Gallery, Inc., New York: plates 43, 49, 80; Helmut Buchen, Cologne, West Germany (courtesy of the artist): plate 98; Rudolph Burckhardt, New York (courtesy of Leo Castelli Gallery): plates 1, 5, 6, 35, 39, 40, 50, 55, 57, 61, 75; Leo Castelli Gallery, New York: plates 2, 3, 7, 10–12, 14, 16–19, 21, 26–28, 30, 32–34, 36, 37, 47, 48, 51, 58, 65, 71, 72, 77, 81, 83–87, 89, 93, 97, 101; Bevan Davies, New York (courtesy of Leo Castelli Gallery): plates 4, 59, 68, 82, 95; O. E. Nelson, New York: plate 74; Jesús F. Patiño, Madrid, Spain (courtesy of the Fondacion Juan March): plates 92, 99, 100, 102; Eric Pollitzer, New York (courtesy of Leo Castelli Gallery): plates 41, 42, 44, 45, 56, 60, 63, 64, 66, 67, 76, 88, 90, 91, 94; David Preston, Southampton, New York: frontispiece, 52–54, 62, 69, 70, 78, 79, 96, 103–6, 114–15.